"The music is not in the notes."
- Wolfgang Amadeus Mozart

HERMANN
—PRESS—

This book presents classical sheet music from the public domain,
meticulously edited by Damian Hermann to closely mirror the original compositions.

Our goal is to deliver an authentic experience and score to our readers.

Published by

www.HermannPress.com

WELCOME

To:

PIANO SONGS
For Advanced Beginners

Unlock the secrets to mastering famous
Piano songs with our proven,
Step-by-Step formula for guaranteed success.

The songs guide you through the timeless eras of
Classical and Romantic music.

Learn from the finest masterpieces like Beethoven's
'Moonlight Sonata' and
Chopin's 'Nocturne' that will take you to the next level.

Enjoy your journey with our best selection and

PLAY YOUR WAY

Audio
Files

INSTRUCTIONS

Each song in this book follows three steps. The first step is the original score. Next you have the version with finger numbers added for all notes. Lastly you'll get the complete score with finger numbers and note letters.

BASIC THEORY: NOTES & CLEFS

The <u>treble clef</u> tells you that the note around the cringle is a 'G'. The <u>bass clef</u> note between the dots is 'F'. The notes have the same note arrangement but the order on the clef is different.

<u>Middle C</u> is above the bass clef and below the treble clef; so these two clefs together cover much of the range of most voices and instruments.

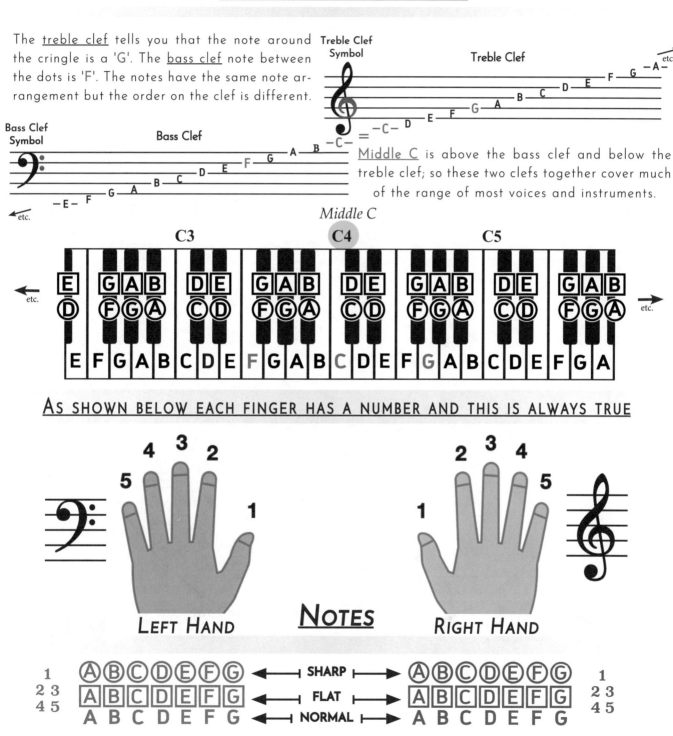

AS SHOWN BELOW EACH FINGER HAS A NUMBER AND THIS IS ALWAYS TRUE

LEFT HAND <u>NOTES</u> RIGHT HAND

<u>BLUE</u> letters/numbers are played by the <u>right hand</u>.
<u>RED</u> letters/numbers are played by the <u>left hand</u>.

Circle of Fifths

The Circle of Fifths is a graphic representation of the relationshiphs between the 12 major and minor keys. A relative minor key exists for every major key. Natural minor scales in relative minor keys share the <u>same notes</u> as the related major scale.

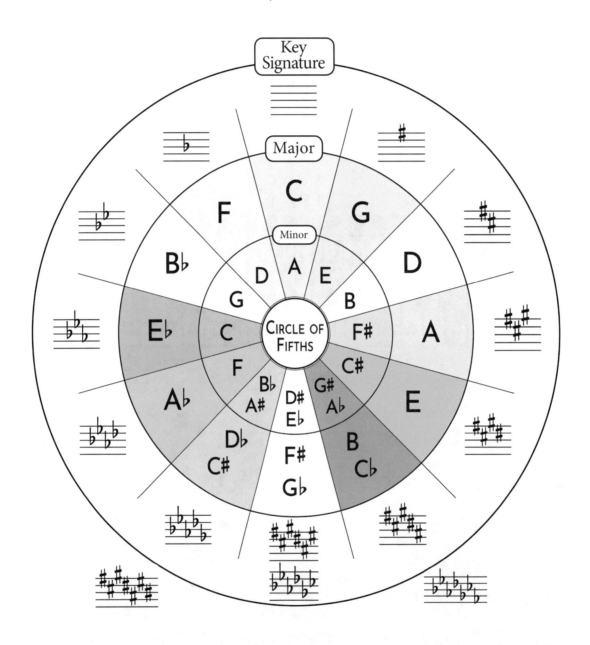

<u>Order of flats (key signature)</u>

B♭, E♭, A♭, D♭, G♭, C♭, F♭

<u>Order of sharps (key signature)</u>

F#, C#, G#, D#, A#, E#, B#

THE ENTERTAINER

SCOTT JOPLIN (1868 - 1917)

Composed in C major (some sections in F major)

BASIC THEORY: NOTES & CLEFS (USEFUL KNOWLEDGE BEFORE YOU START PLAYING)

Notes of the Scale:		Key Signature:
C, D, E, F, G, A, B	C major	No Flats / No Sharps

Relative Key:		Link to Audio File:
A minor		https://drive.google.com/file/d/1CdcgQ2Bo fUC9U6IDB1nrv_EbKl-AMfzg/view

Practice the scale with your <u>RIGHT HAND (2 OCTAVES)</u>. Pay attention to <u>ACCIDENTALS (Key Signature)</u>.

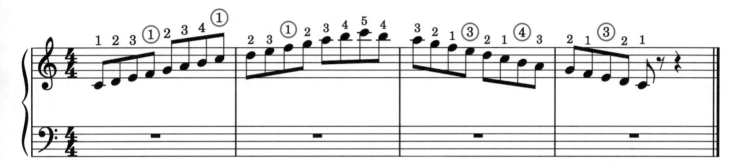

Practice the scale with your <u>LEFT HAND (2 OCTAVES)</u>. Pay attention to <u>ACCIDENTALS (Key Signature)</u>.

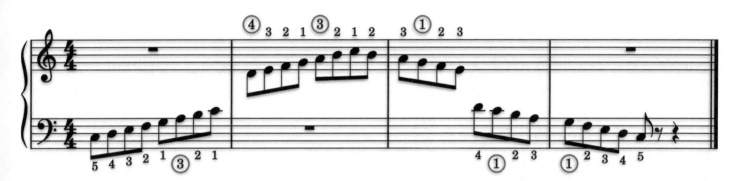

Practice CHORDS & INVERSIONS (BOTH HANDS) <u>1st & 2nd Inversions: Root note 'E' & Root note 'G'</u>.

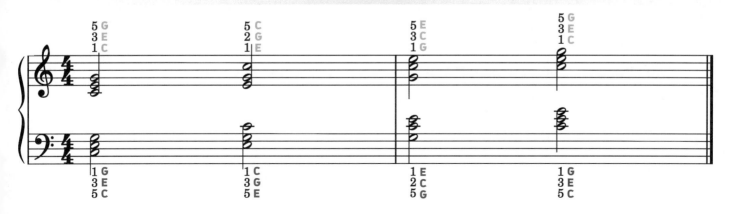

PRACTICE TIPS

Scott Joplin composed "The Entertainer" in 1902. It is one of the most famous ragtime pieces, known for its syncopated rhythms and lively, playful melody. Playing this piece can help pianists improve their timing and finger agility, making it an enjoyable way to develop technical skills while exploring the lively, spirited style of early American music.

The following tips will help you to practice and become better.

1. START SLOW
It is very important to play each note correctly, and doing so at a low speed first helps you build the necessary muscle memory. Don't worry about keeping up with the original speed or setting a metronome.

2. FINGER NUMBERING
Pay close attention to the finger numbers, especially in the number version of your sheet music.. Remember that to play smoothly, you need to be able to place and move your hands well.

3. PAY ATTENTION TO THE RHYTHM
A metronome can be very helpful. Set the speed to a low level first, and as you get used to the beats, slowly speed it up.

4. BREAK IT DOWN
Focus on small areas at a time. Mastering a few measures at a time can help you feel more confident and make sure you play correctly.

5. SEPARATE, THEN TOGETHER
Work on each hand separately to focus on its difficulties. As soon as you feel ready, start playing with both hands.

6. READ THE NOTES
Practice reading the original score. If you are unsure, go to the third version and look up the name. This helps you become a better musician, learn more songs in the future, and move past the beginning level.

7. SAY OR SING
Say or sing the note names out loud as you play from the version with the note names. This will help you remember where the sounds are on the piano and the staff.

8. RECORD YOURSELF
Document your practice lessons from time to time so you see what you need to work on and how you're doing by listening back over time.

9. REGULAR PRACTICE
It's important to practice often. Also, having short daily practices is better than long ones less often. Being consistent is key and will bring you the best results.

10. THINK ABOUT FINGER TRANSITIONS
Consider how the fingers change places, especially where the finger numbers are shown. Composers also include those numbers in original scores because your performance will sound better and flow better if you use smooth changes.

The Entertainer

SCOTT JOPLIN.

Not fast.

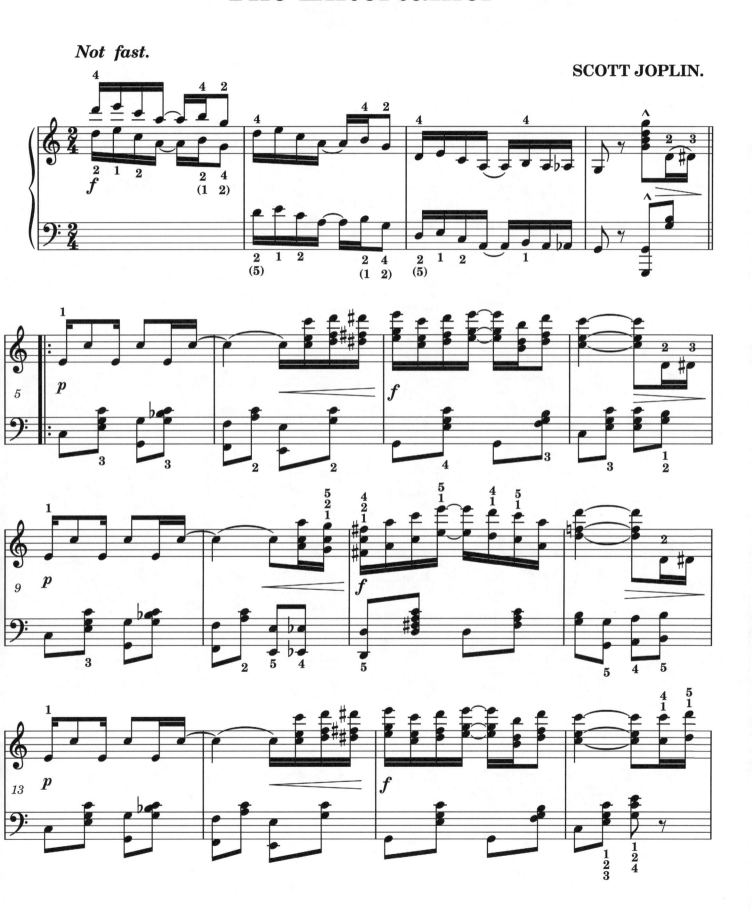

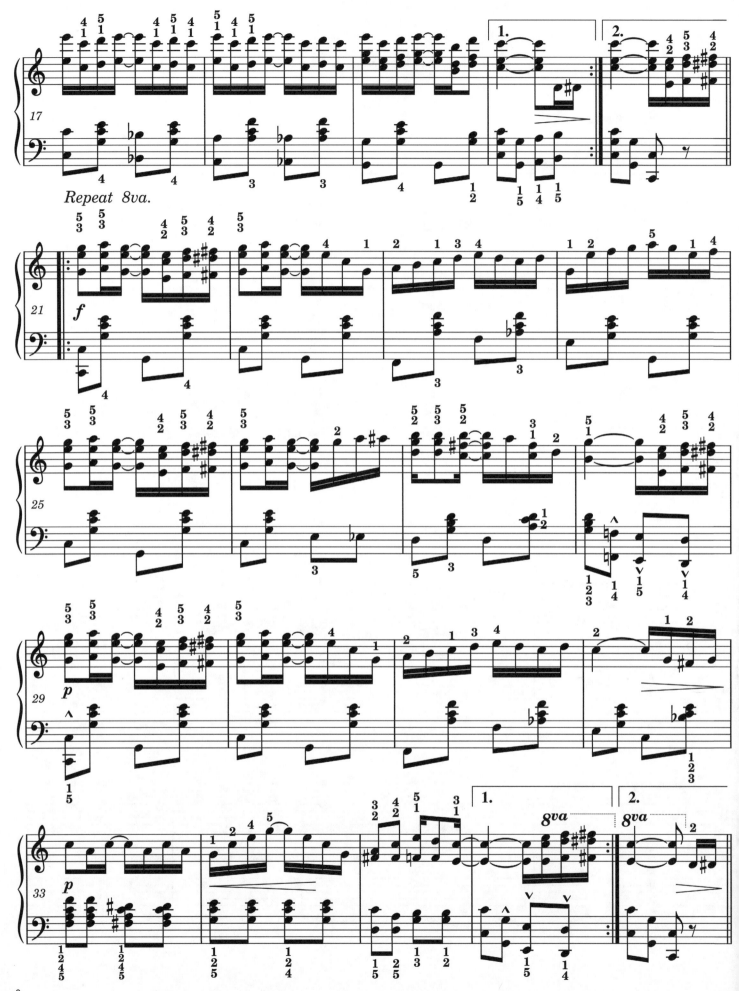

Repeat 8va.

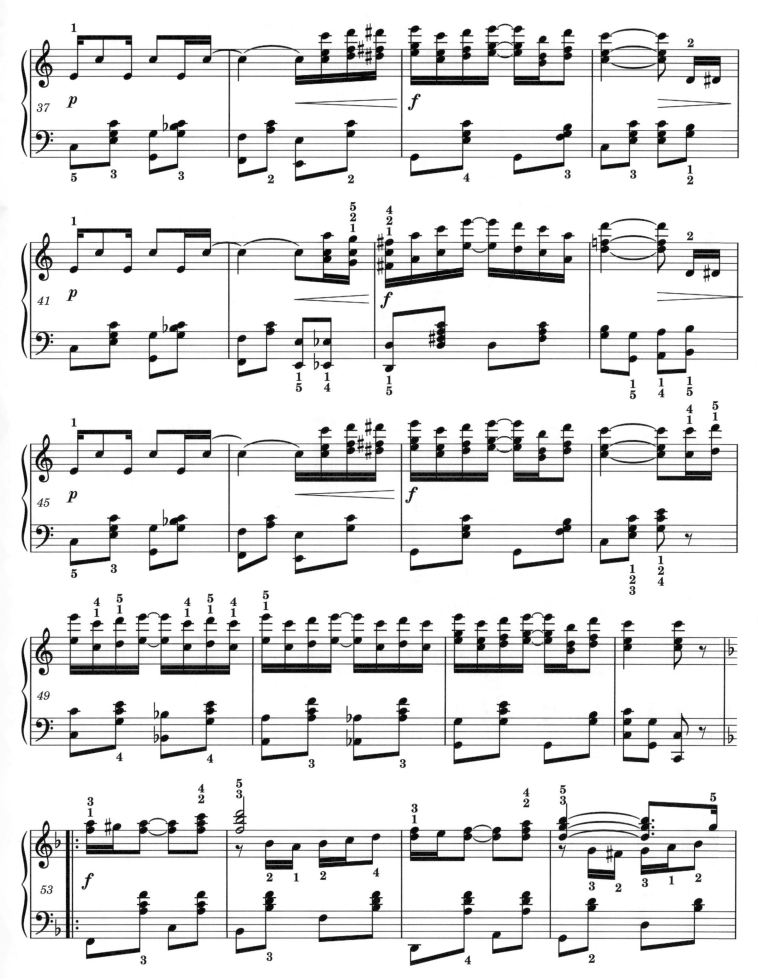

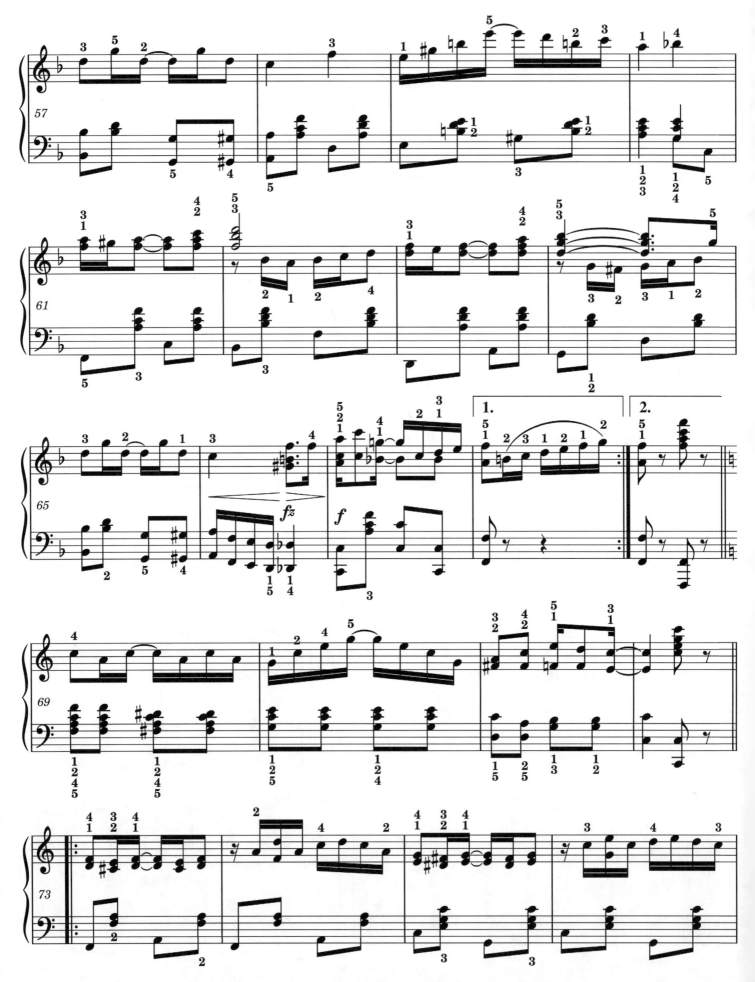

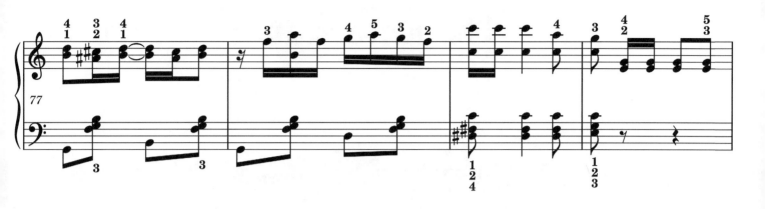

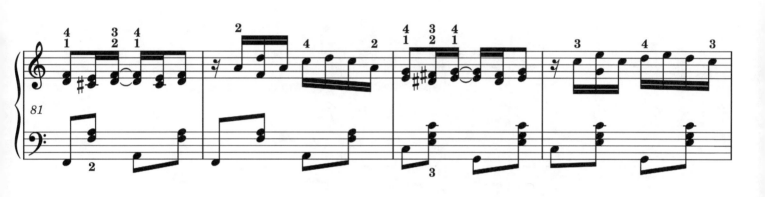

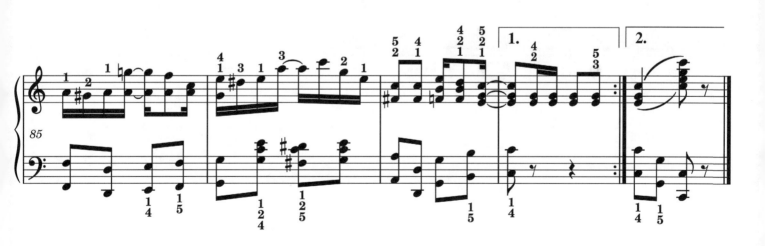

The Entertainer

SCOTT JOPLIN.

Not fast.

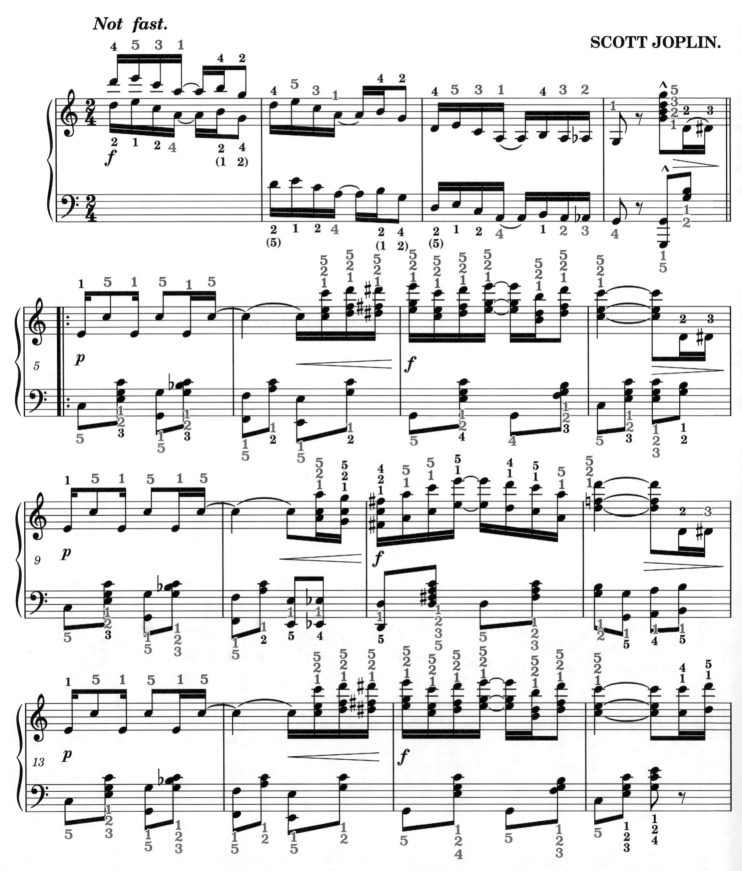

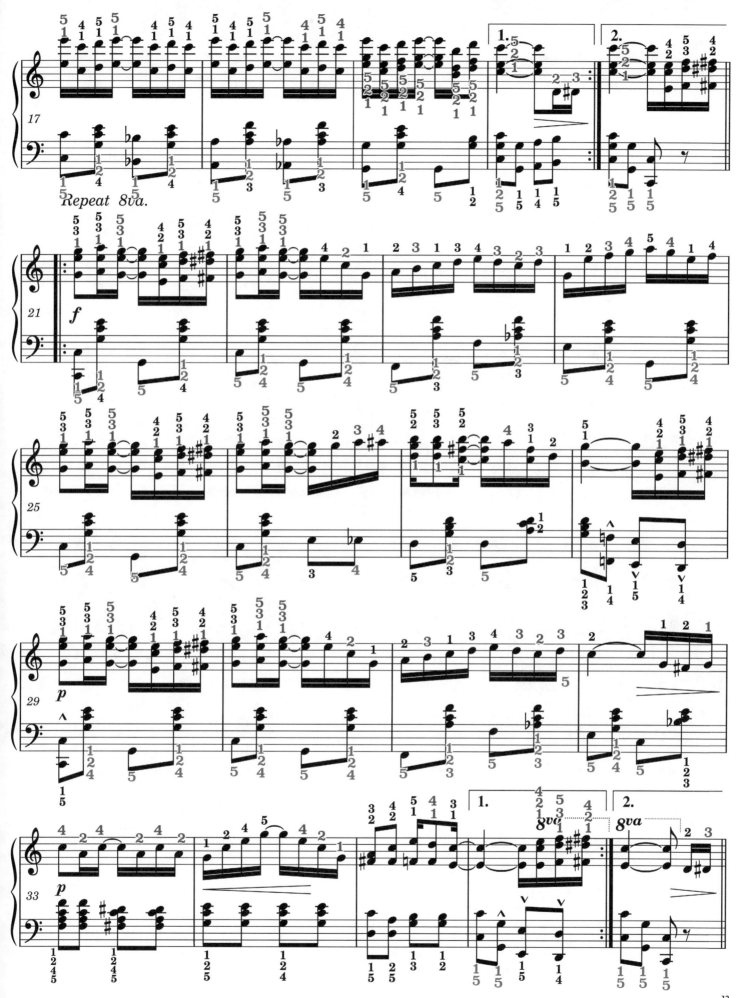

Repeat 8va.

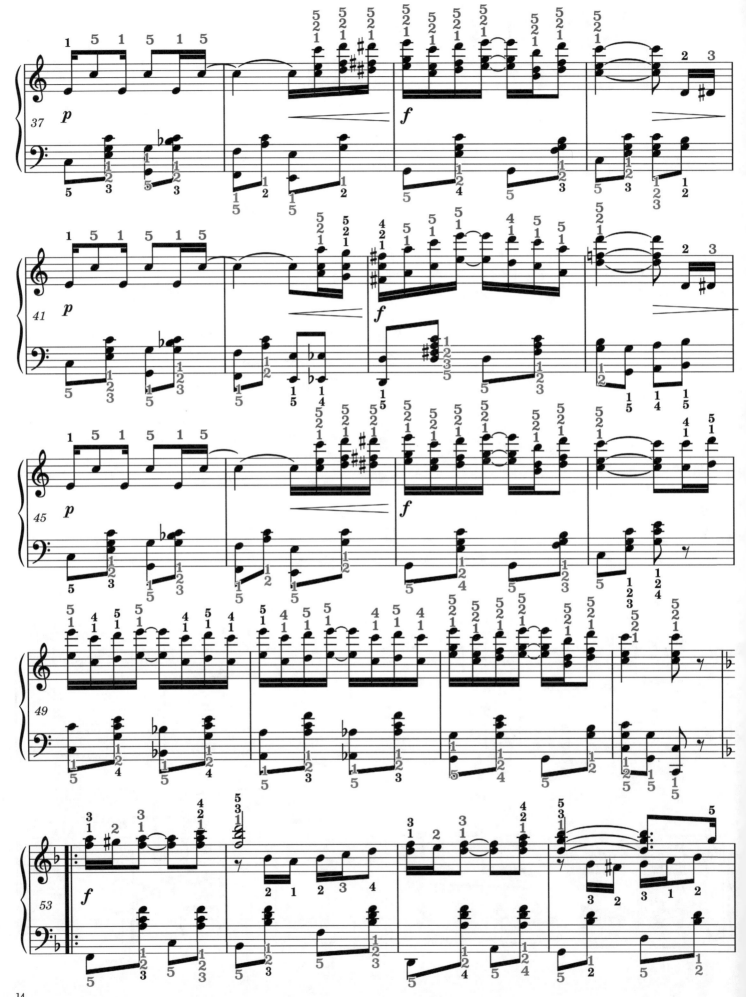

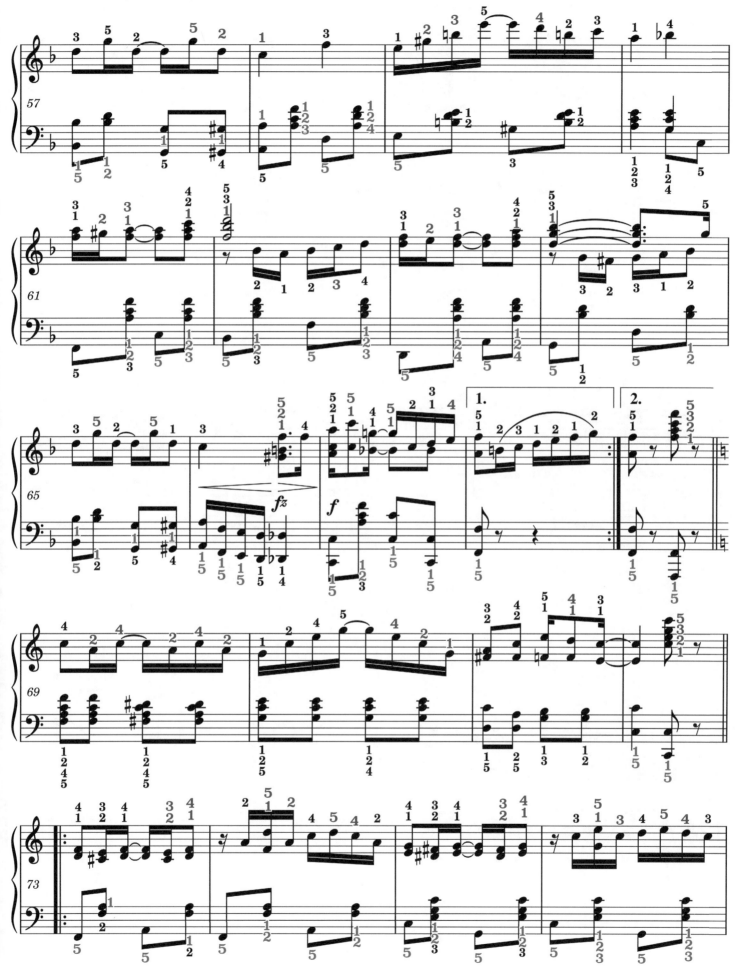

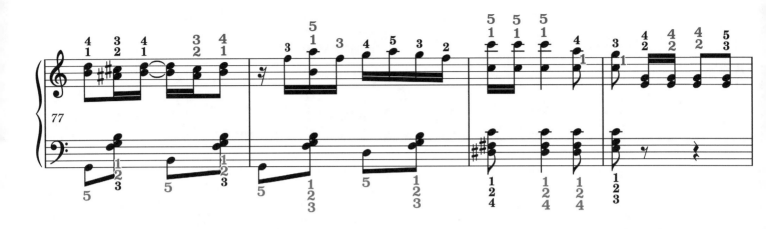

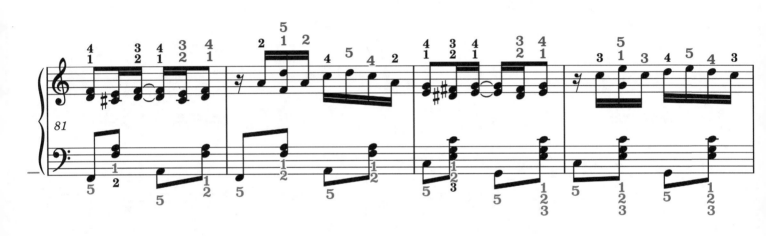

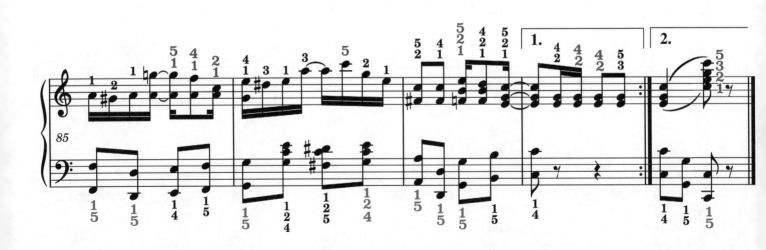

The Entertainer

SCOTT JOPLIN.

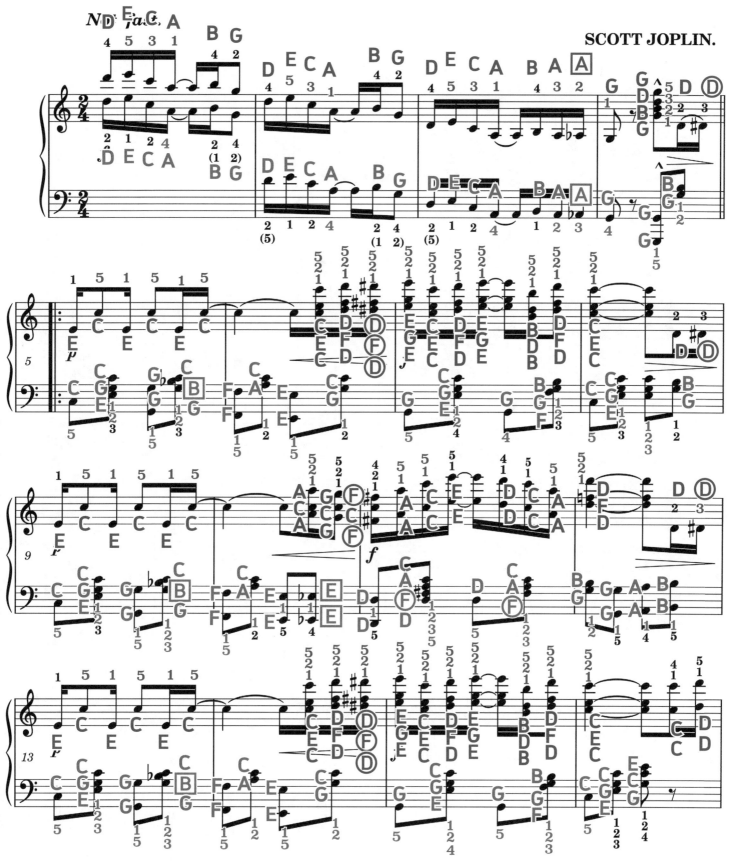

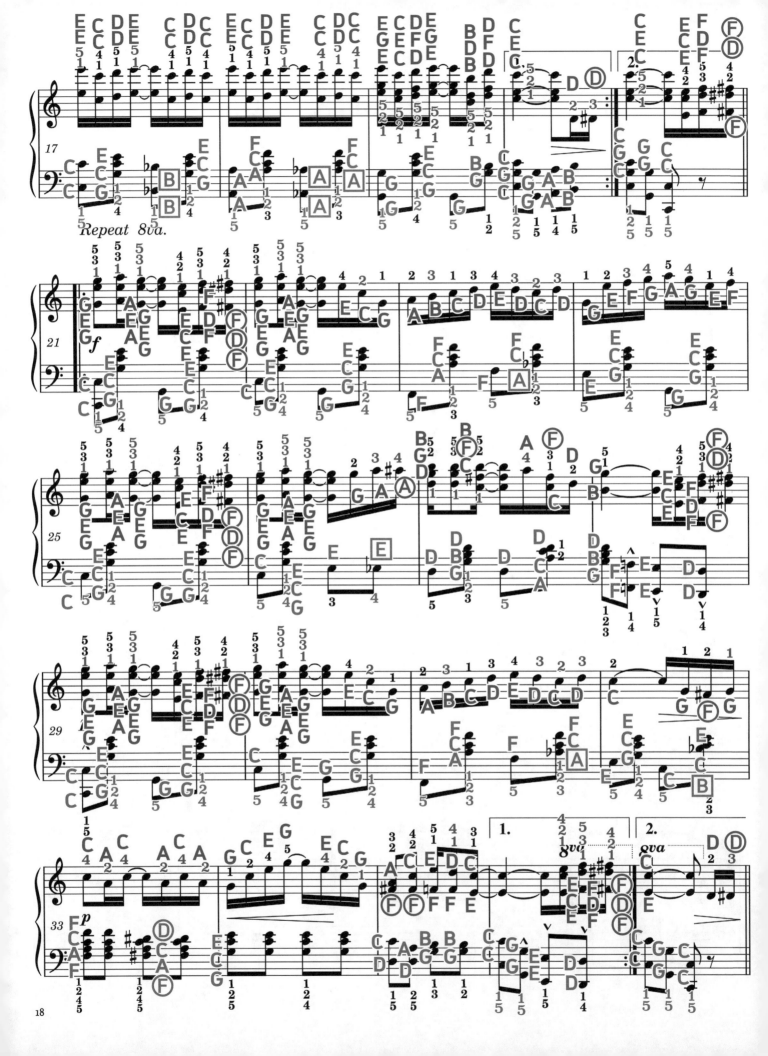

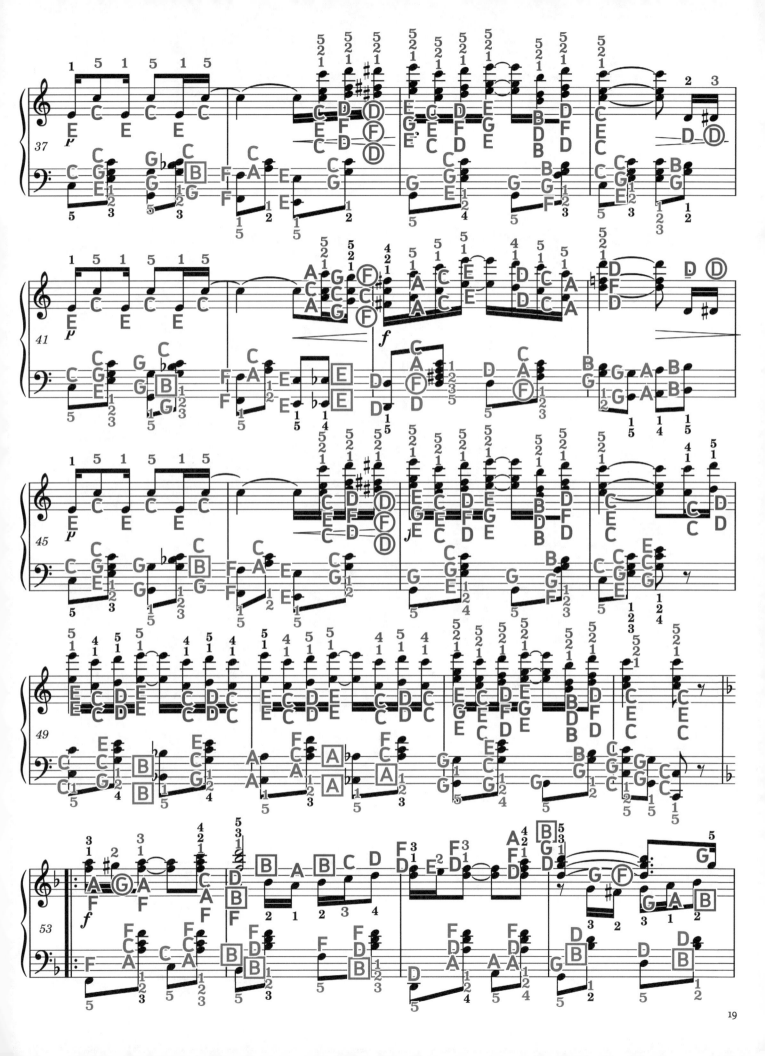

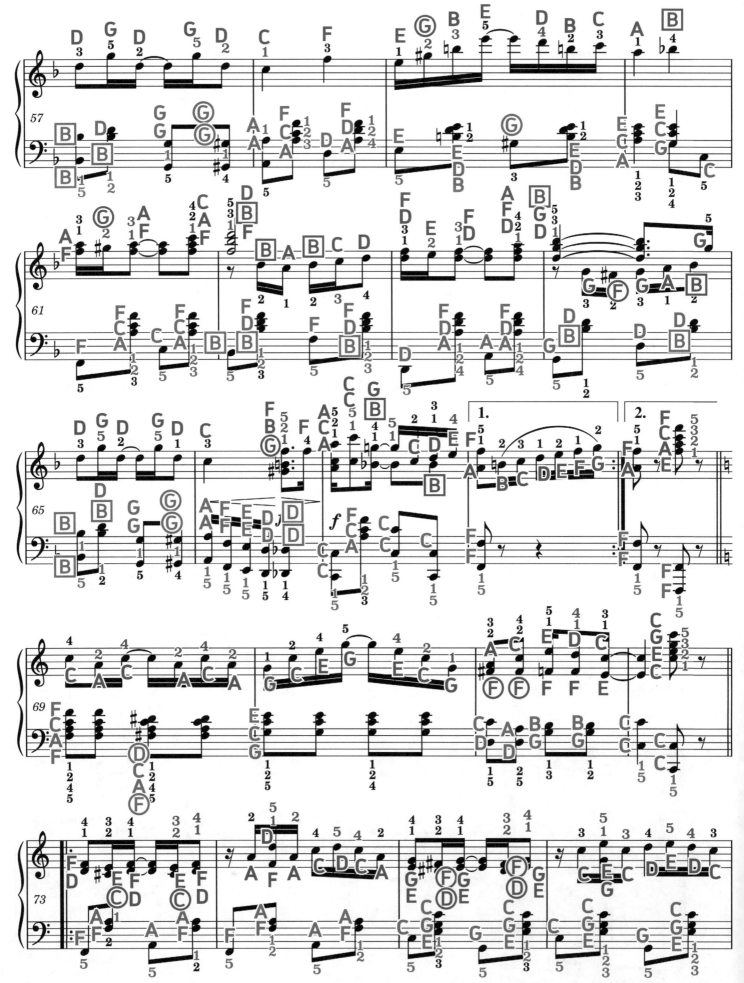

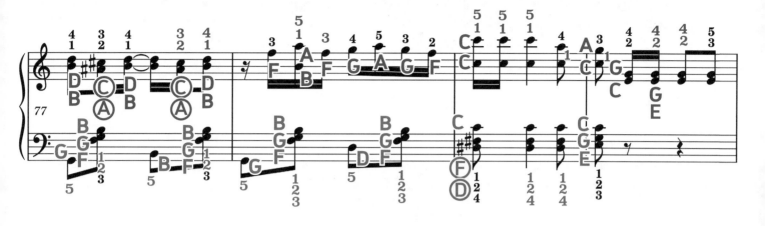

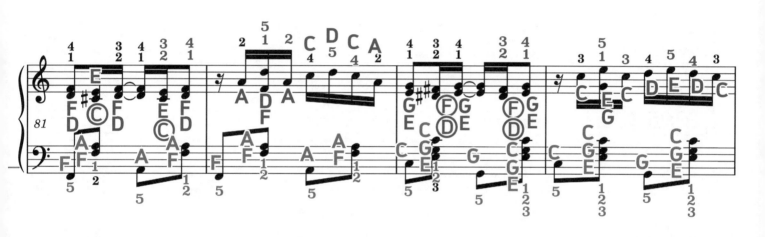

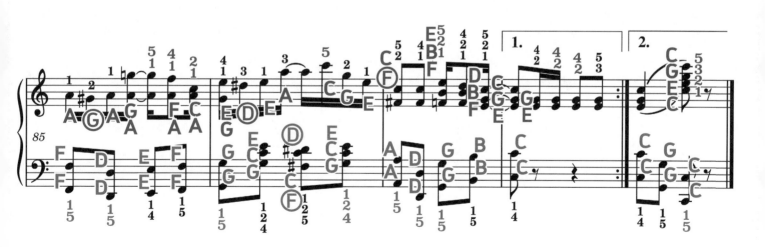

MOONLIGHT SONATA

LUDWIG VAN BEETHOVEN (1770 - 1827)
Composed in C# minor

BASIC THEORY: NOTES & CLEFS (USEFUL KNOWLEDGE BEFORE YOU START PLAYING)

Notes of the Scale:
C#, D#, E, F#, G#, A, B

Relative Key:
E major

C# minor

Key Signature:
Four Sharps (F#, C#, G#, D#)

Link to Audio File:
https://drive.google.com/file/d/1W0zmMFz
8jMGKKxPJb53hM_EeiZV6IziV/view?usp=sharing

Practice the scale with your <u>RIGHT HAND (2 OCTAVES)</u>. Pay attention to <u>ACCIDENTALS</u> (Key Signature).

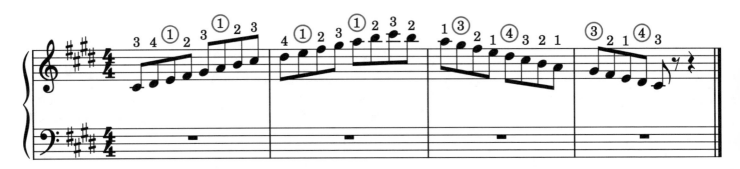

Practice the scale with your <u>LEFT HAND (2 OCTAVES)</u>. Pay attention to <u>ACCIDENTALS</u> (Key Signature).

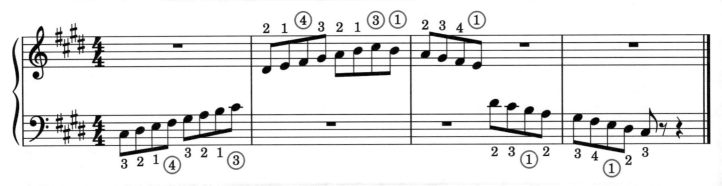

Practice CHORDS & INVERSIONS (BOTH HANDS) <u>1st & 2nd Inversions</u>: Root note 'E' & Root note 'G#'.

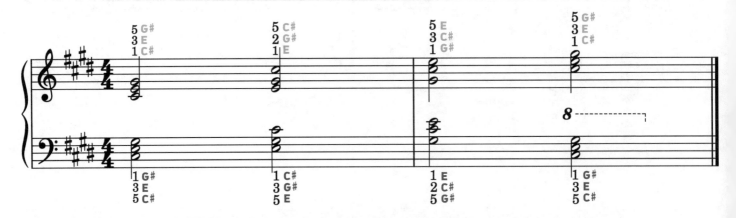

PRACTICE TIPS

The first movement of the "Moonlight Sonata" was composed by Ludwig van Beethoven in 1801. It is well-known for its profound and almost meditative atmosphere. The movement features a persistent triplet rhythm and a lyrical melody, making it an excellent piece for advanced beginners to study controlled expression and subtle dynamics.

The following tips will help you to practice and become better.

1. START SLOW
It is very important to play each note correctly, and doing so at a low speed first helps you build the necessary muscle memory. Don't worry about keeping up with the original speed or setting a metronome.

2. FINGER NUMBERING
Pay close attention to the finger numbers, especially in the number version of your sheet music.. Remember that to play smoothly, you need to be able to place and move your hands well.

3. PAY ATTENTION TO THE RHYTHM
A metronome can be very helpful. Set the speed to a low level first, and as you get used to the beats, slowly speed it up.

4. BREAK IT DOWN
Focus on small areas at a time. Mastering a few measures at a time can help you feel more confident and make sure you play correctly.

5. SEPARATE, THEN TOGETHER
Work on each hand separately to focus on its difficulties. As soon as you feel ready, start playing with both hands.

6. READ THE NOTES
Practice reading the original score. If you are unsure, go to the third version and look up the name. This helps you become a better musician, learn more songs in the future, and move past the beginning level.

7. SAY OR SING
Say or sing the note names out loud as you play from the version with the note names. This will help you remember where the sounds are on the piano and the staff.

8. RECORD YOURSELF
Document your practice lessons from time to time so you see what you need to work on and how you're doing by listening back over time.

9. REGULAR PRACTICE
It's important to practice often. Also, having short daily practices is better than long ones less often. Being consistent is key and will bring you the best results.

10. THINK ABOUT FINGER TRANSITIONS
Consider how the fingers change places, especially where the finger numbers are shown. Composers also include those numbers in original scores because your performance will sound better and flow better if you use smooth changes.

Sonate No. 14, *Moonlight*

1st Movement

Opus 27 No. 2

Ludwig van Beethoven
(1770–1827)

Adagio sostenuto

Si deve suonare tutto questo pezzo delicatissimamente e senza sordini

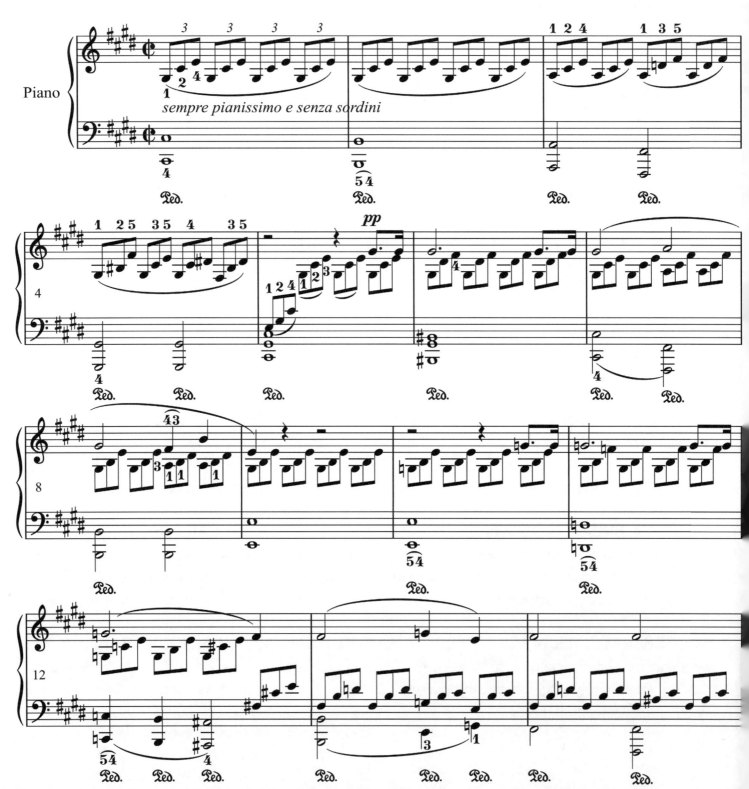

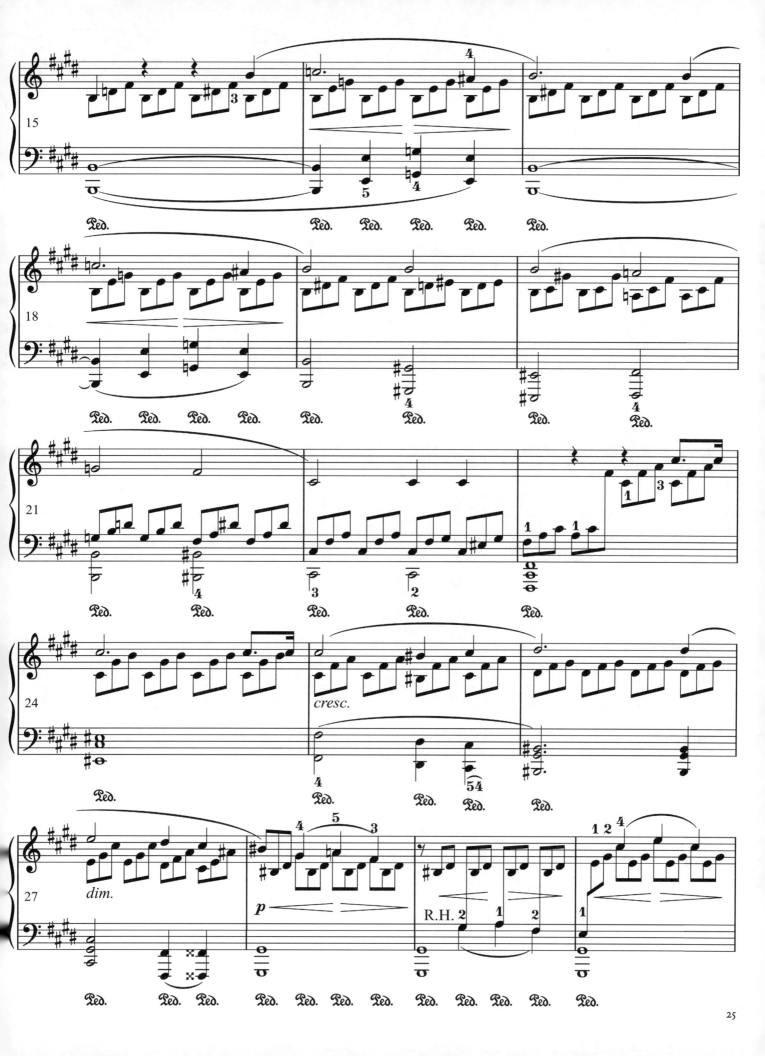

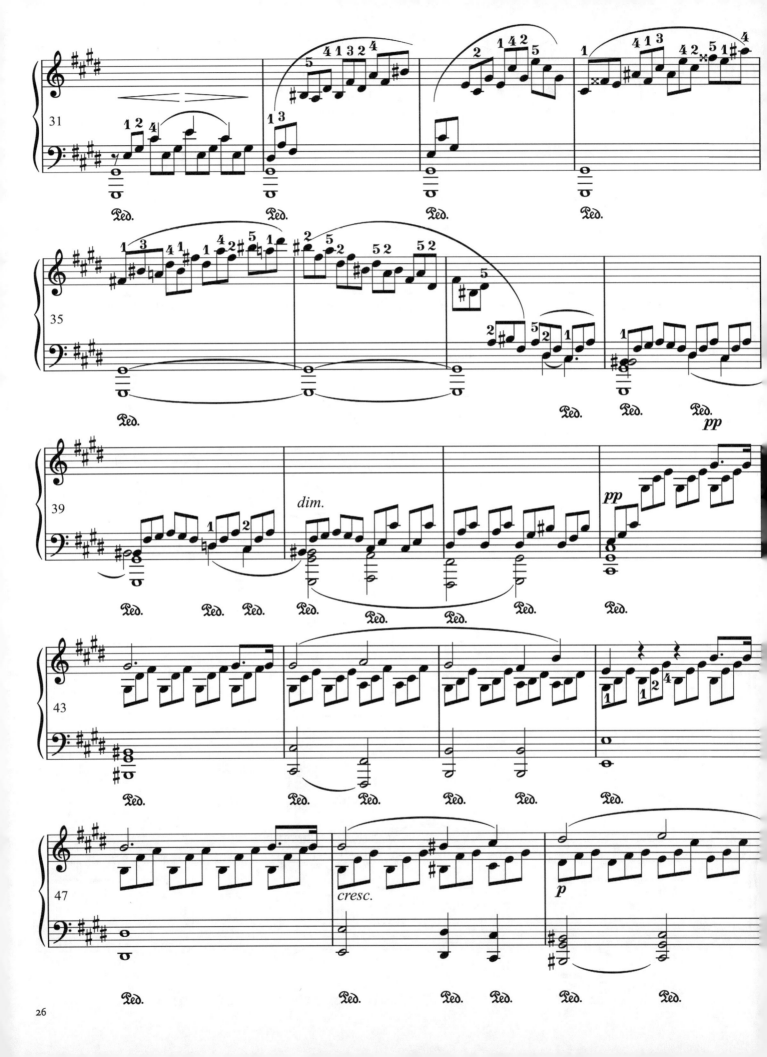

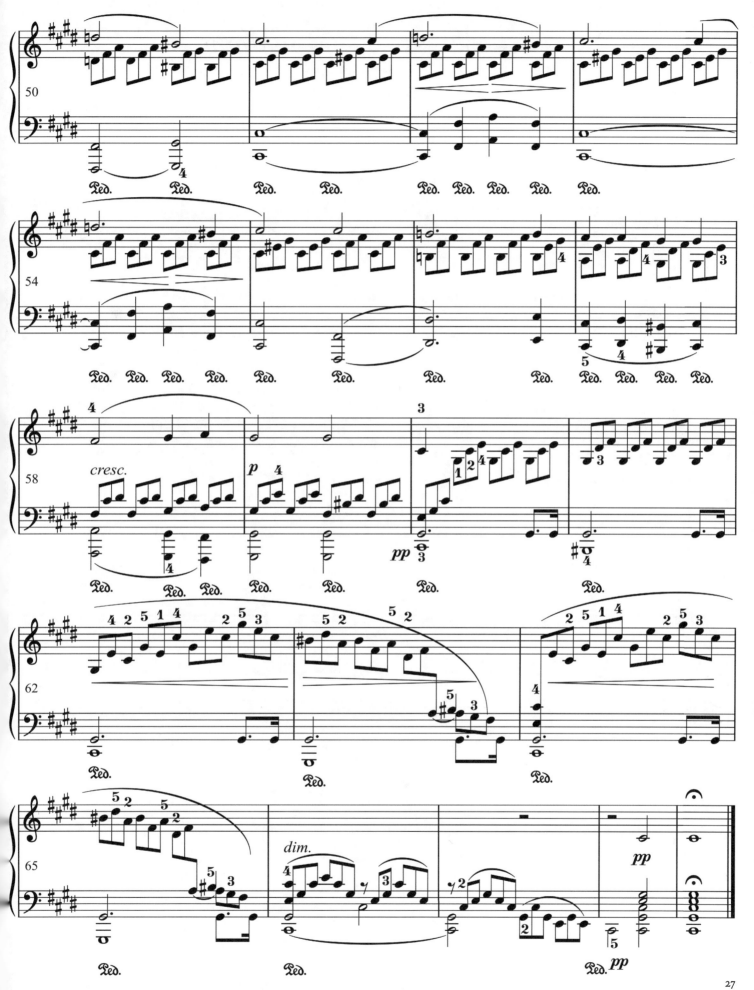

Sonate No. 14, *Moonlight*

1st Movement
Opus 27 No. 2

Ludwig van Beethoven
(1770–1827)

Adagio sostenuto
Si deve suonare tutto questo pezzo delicatissimamente e senza sordini

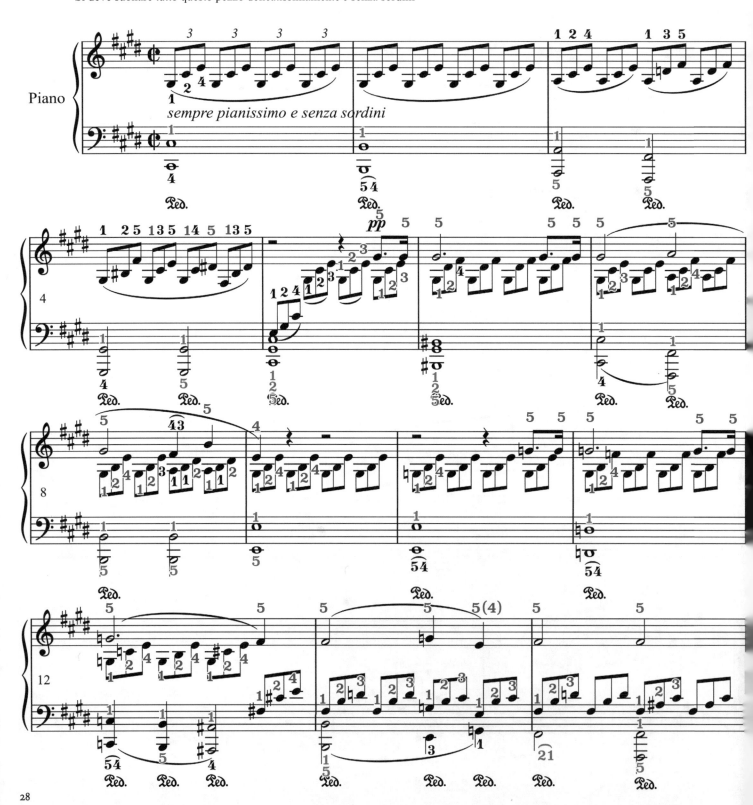

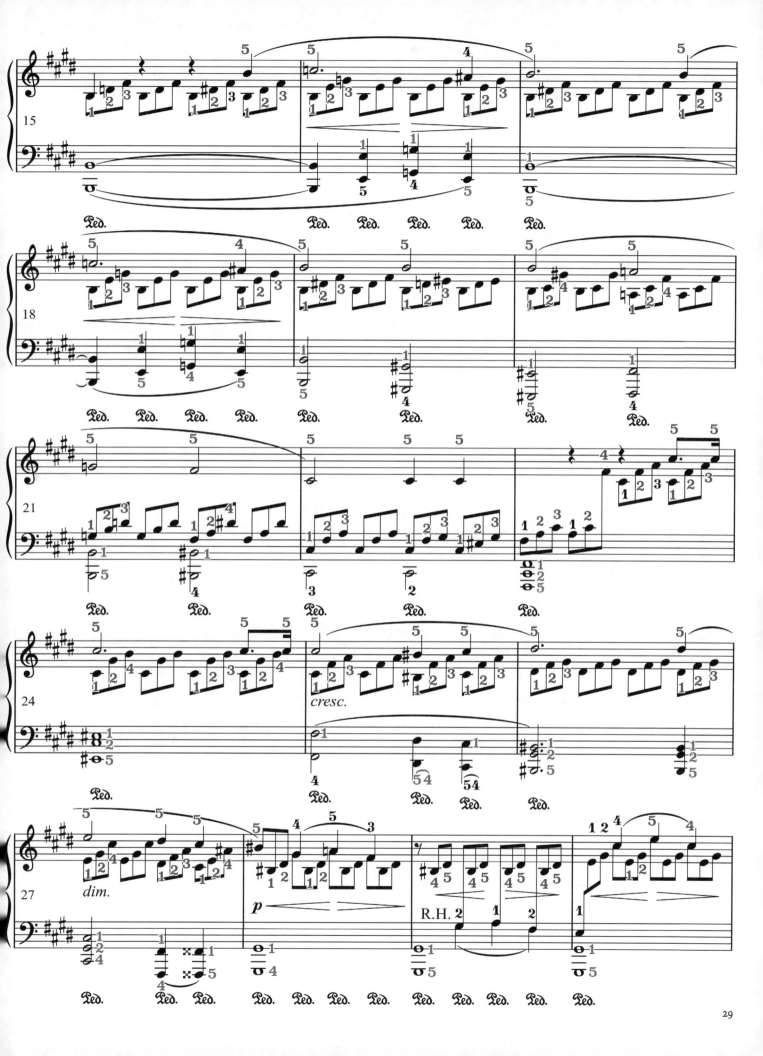

29

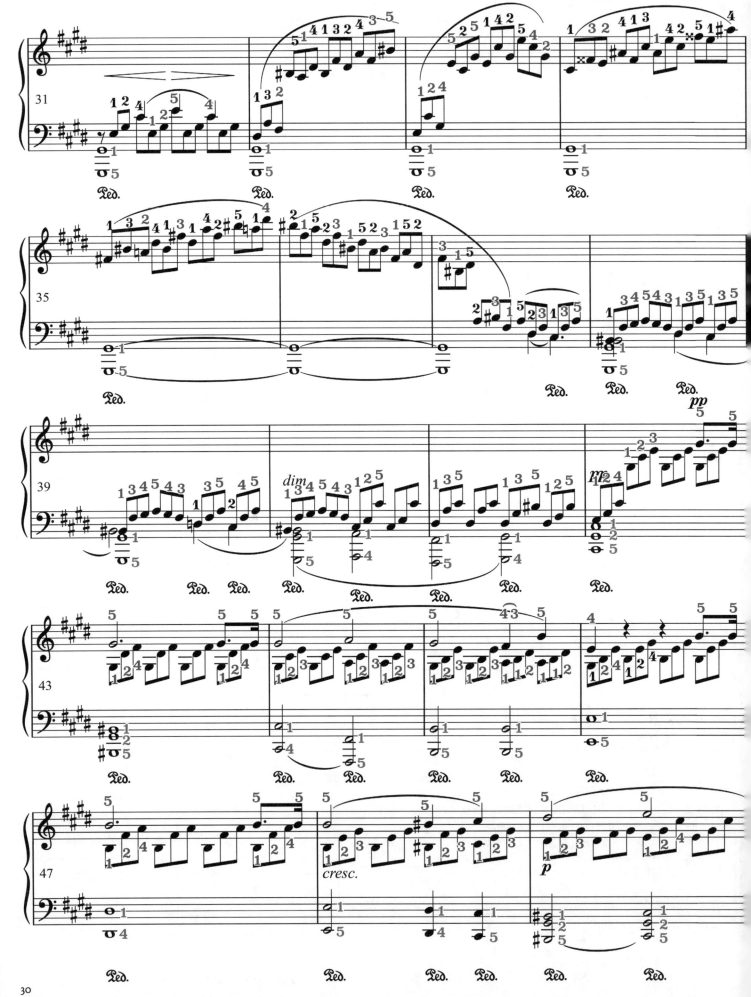

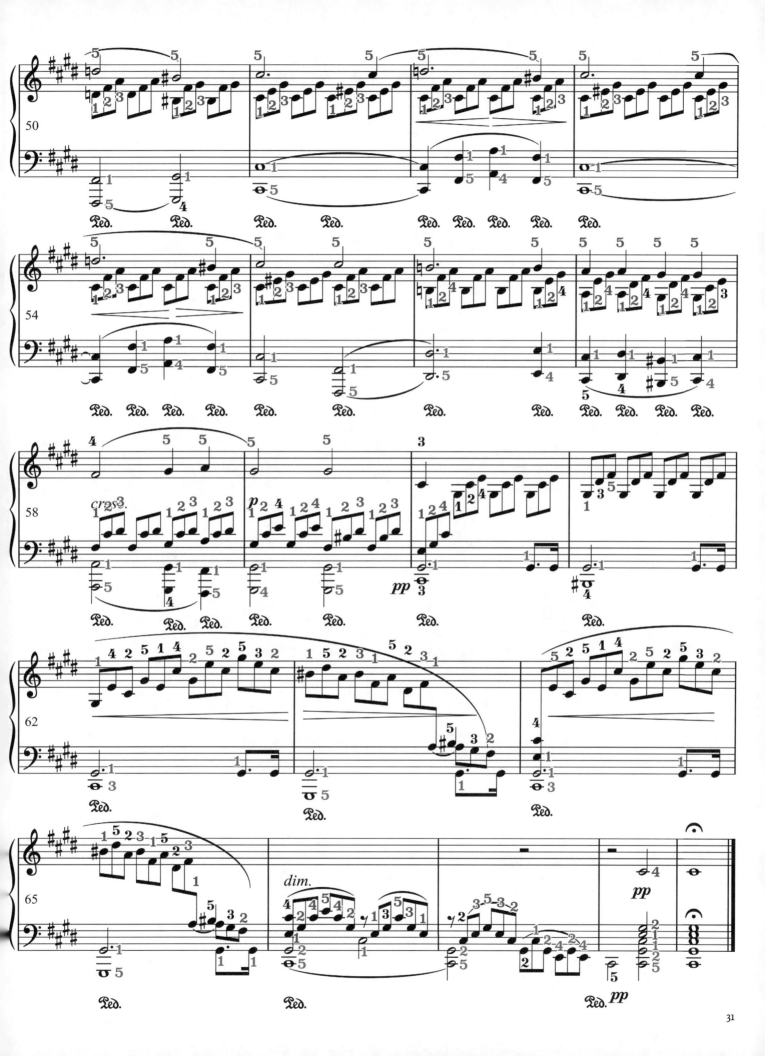

Sonate No. 14, *Moonlight*

1st Movement
Opus 27 No. 2

Ludwig van Beethoven
(1770–1827)

Adagio sostenuto

Si deve suonare tutto questo pezzo delicatissimamente e senza sordini

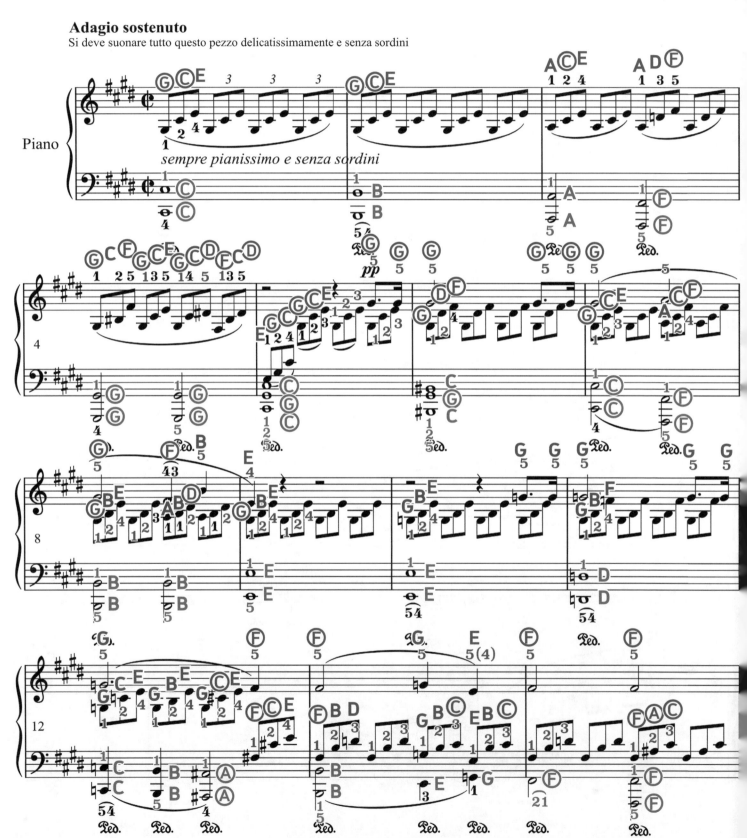

sempre pianissimo e senza sordini

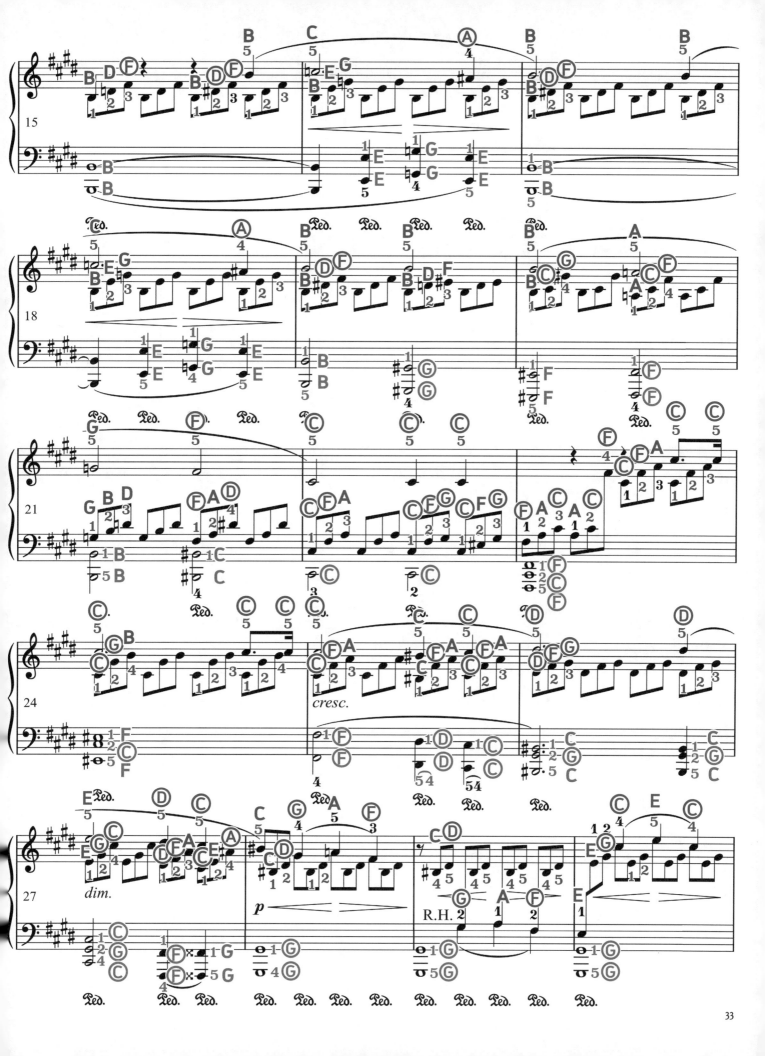

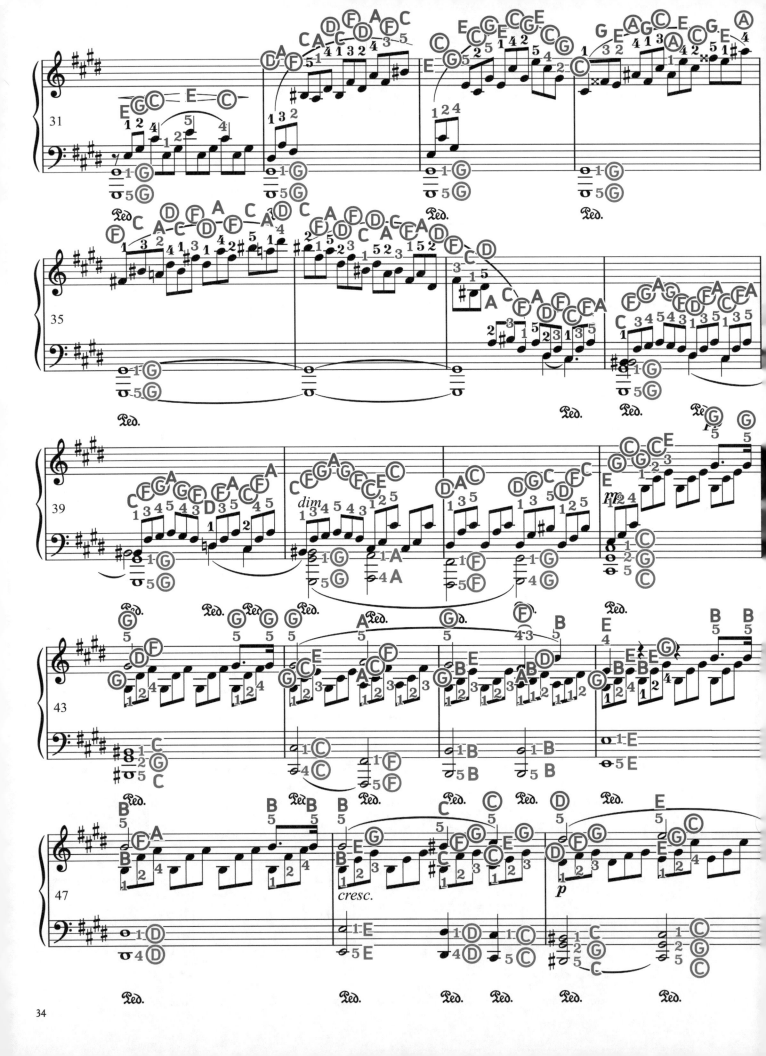

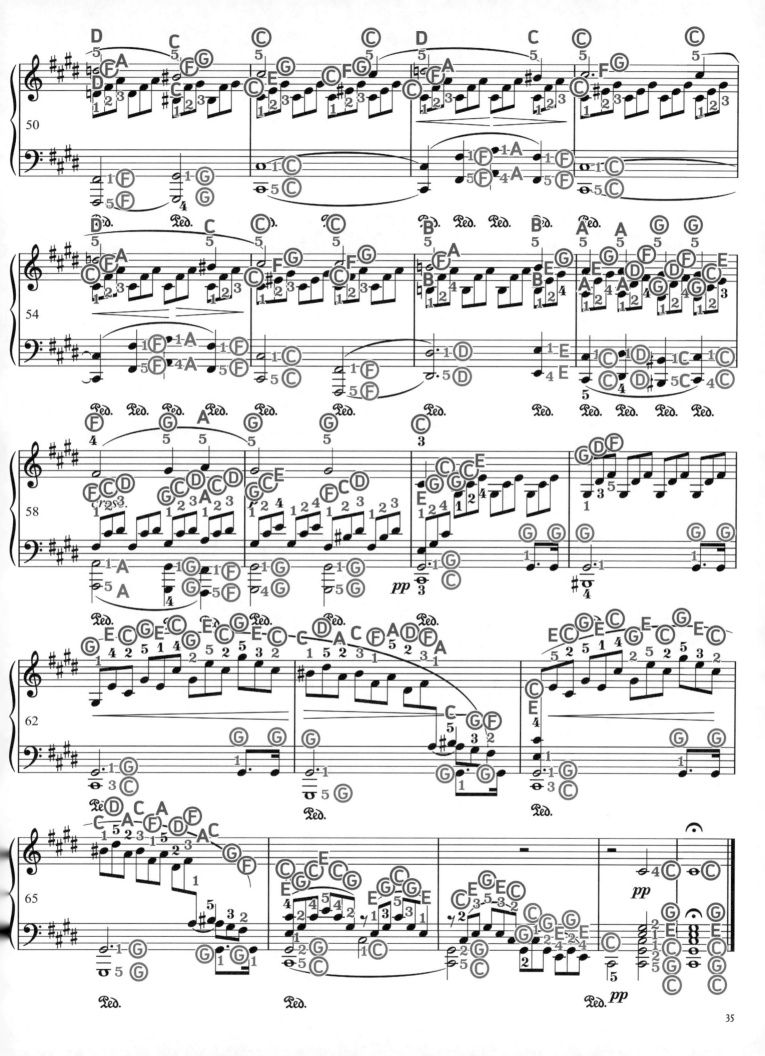

LIEBESTRAUM NO 3

FRANZ LISZT (1811 - 1886)
Composed in A♭ major

BASIC THEORY: NOTES & CLEFS (USEFUL INFORMATION BEFORE YOU PLAY THE SONG)

Notes of the Scale:
A♭, B♭, C, D♭, E♭, F, G

Relative Key:
F minor

A♭ major

Key Signature:
Four Flats (B♭, E♭, A♭, D♭)

Link to Audio File:
https://drive.google.com/file/d/1zVoYU6x
OkBQVApgjdQ9u8FzJp_5QEVHh/view

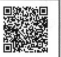

Practice the scale with your <u>RIGHT HAND (2 OCTAVES)</u>. Pay attention to <u>ACCIDENTALS (Key Signature)</u>.

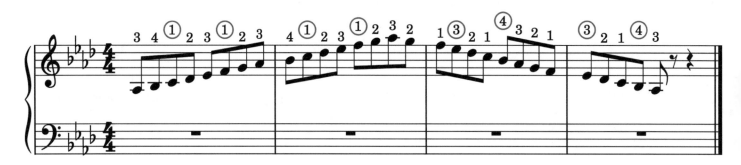

Practice the scale with your <u>LEFT HAND (2 OCTAVES)</u>. Pay attention to <u>ACCIDENTALS (Key Signature)</u>.

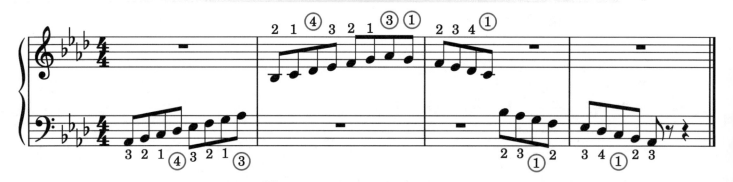

Practice CHORDS & INVERSIONS (BOTH HANDS) <u>1st & 2nd Inversions: Root note 'C' & Root note 'E♭'</u>.

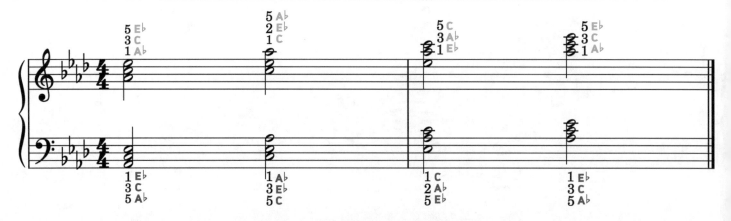

PRACTICE TIPS

"Liebestraum No. 3" by Franz Liszt, composed in 1850, is a quintessential Romantic-era piece. "Liebestraum" translates from german to "Dream of Love." This piece is known for its tender, flowing melody and rich harmonies. It helps pianists develop dynamic control and expressive phrasing, making it a rewarding challenge for those exploring deeper emotional expression in their playing.

The following tips will help you to practice and become better.

1. START SLOW
It is very important to play each note correctly, and doing so at a low speed first helps you build the necessary muscle memory. Don't worry about keeping up with the original speed or setting a metronome.

2. FINGER NUMBERING
Pay close attention to the finger numbers, especially in the number version of your sheet music.. Remember that to play smoothly, you need to be able to place and move your hands well.

3. PAY ATTENTION TO THE RHYTHM
A metronome can be very helpful. Set the speed to a low level first, and as you get used to the beats, slowly speed it up.

4. BREAK IT DOWN
Focus on small areas at a time. Mastering a few measures at a time can help you feel more confident and make sure you play correctly.

5. SEPARATE, THEN TOGETHER
Work on each hand separately to focus on its difficulties. As soon as you feel ready, start playing with both hands.

6. READ THE NOTES
Practice reading the original score. If you are unsure, go to the third version and look up the name. This helps you become a better musician, learn more songs in the future, and move past the beginning level.

7. SAY OR SING
Say or sing the note names out loud as you play from the version with the note names. This will help you remember where the sounds are on the piano and the staff.

8. RECORD YOURSELF
Document your practice lessons from time to time so you see what you need to work on and how you're doing by listening back over time.

9. REGULAR PRACTICE
It's important to practice often. Also, having short daily practices is better than long ones less often. Being consistent is key and will bring you the best results.

10. THINK ABOUT FINGER TRANSITIONS
Consider how the fingers change places, especially where the finger numbers are shown. Composers also include those numbers in original scores because your performance will sound better and flow better if you use smooth changes.

Liebesträume No. 3

Franz Liszt
(1811–1886)

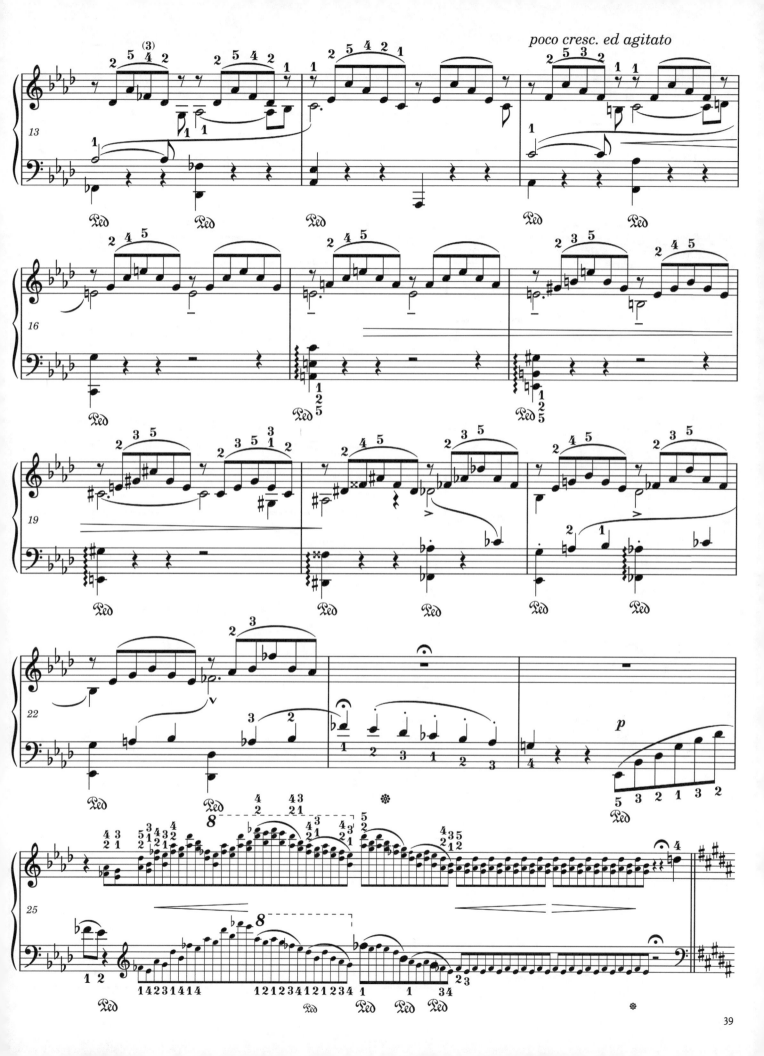

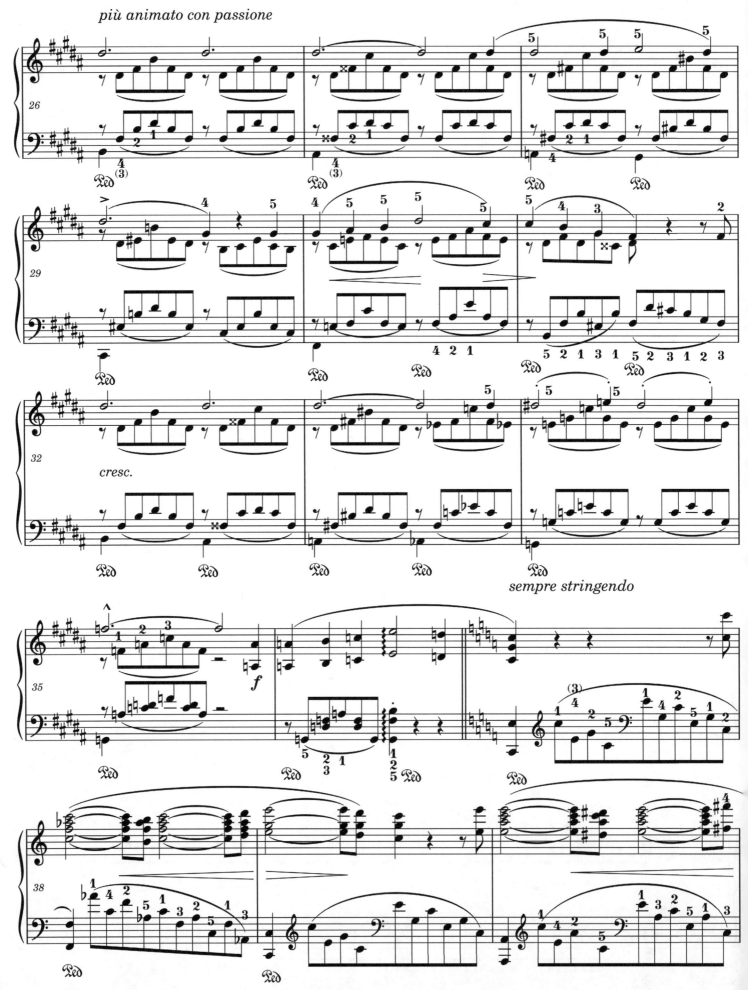

più animato con passione

cresc.

sempre stringendo

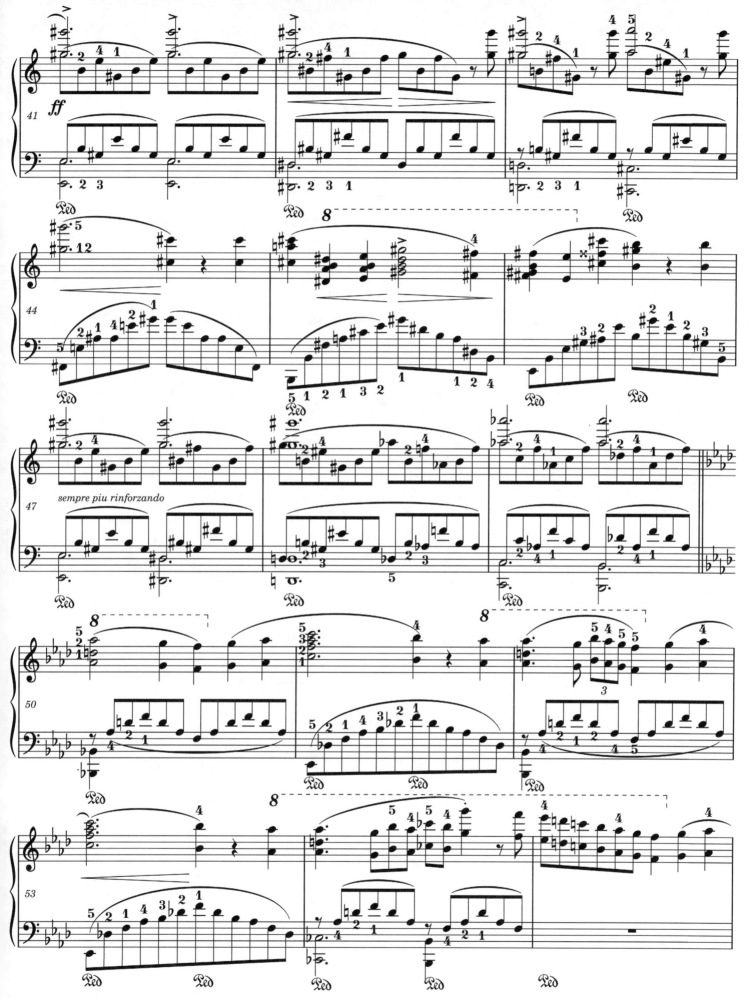

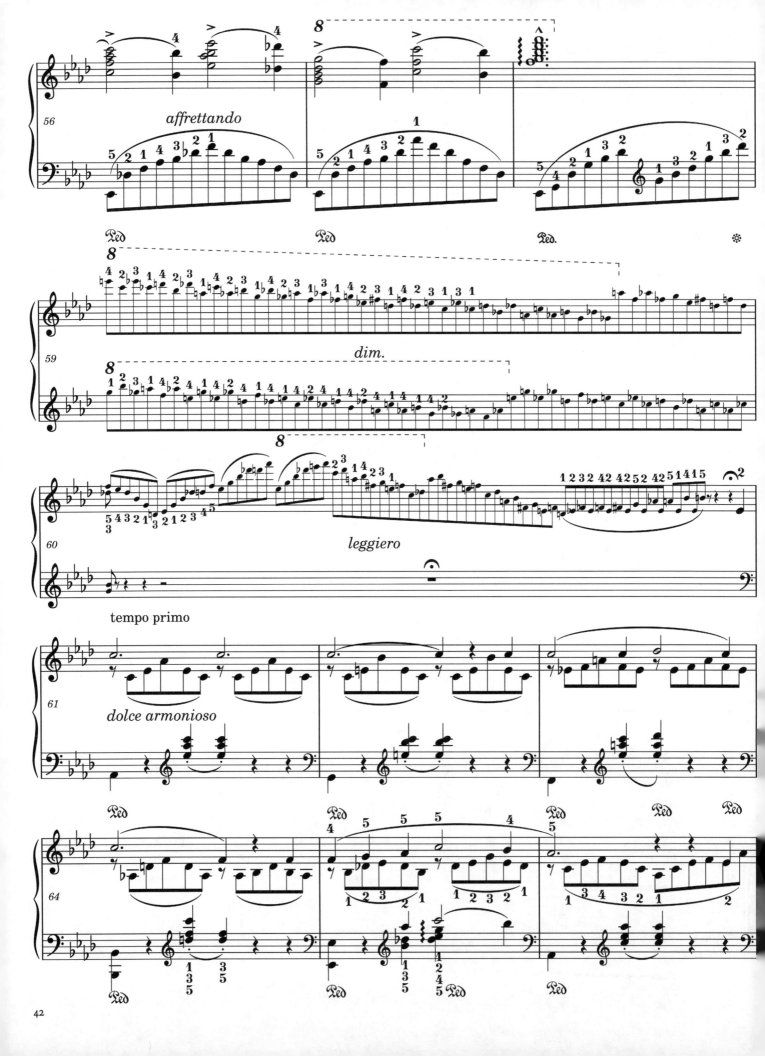

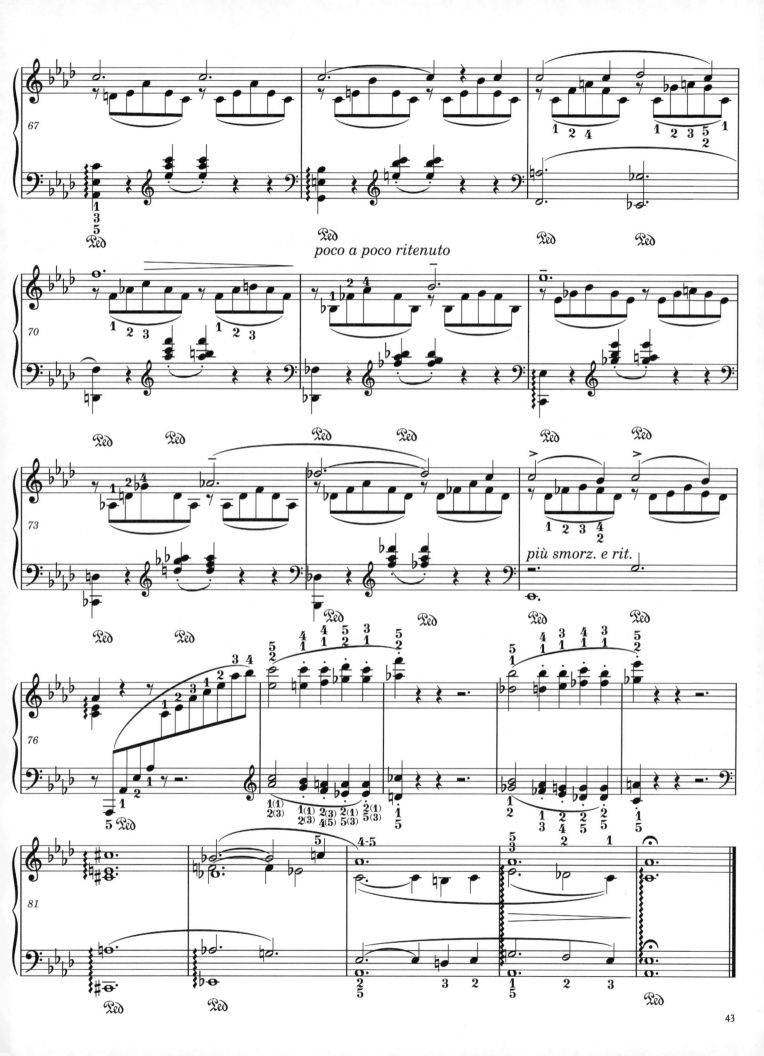

poco a poco ritenuto

più smorz. e rit.

Liebesträume No. 3

Franz Liszt
(1811–1886)

Poco allegro, con affetto

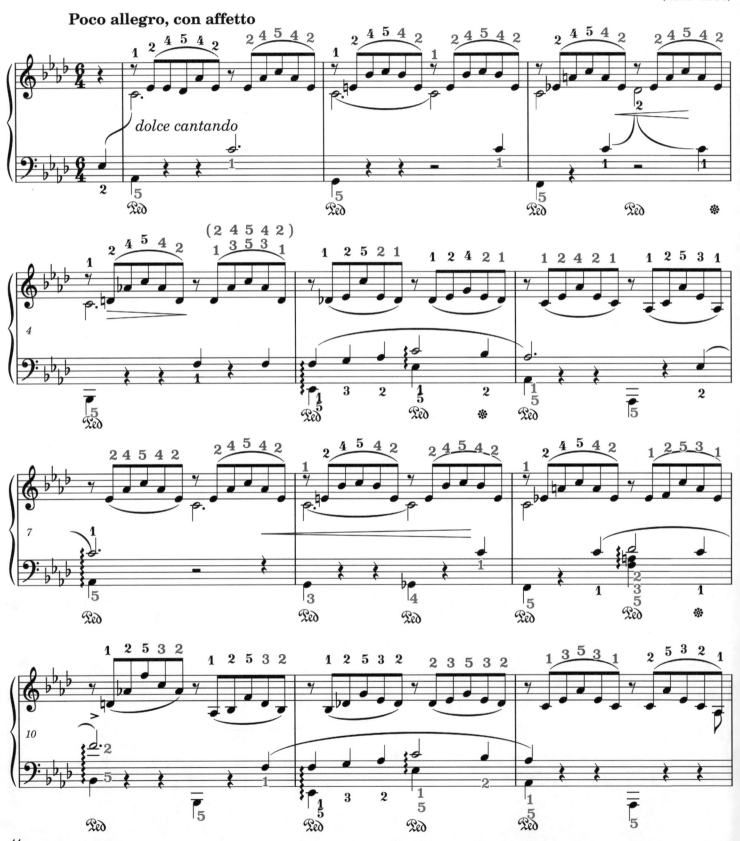

dolce cantando

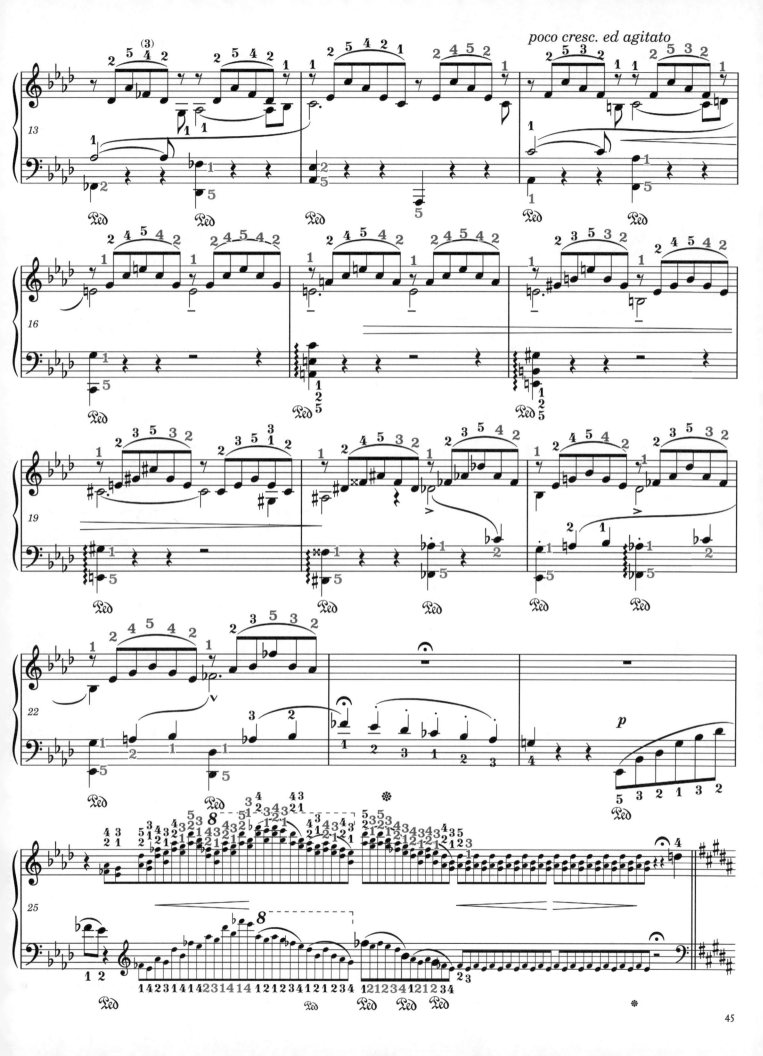

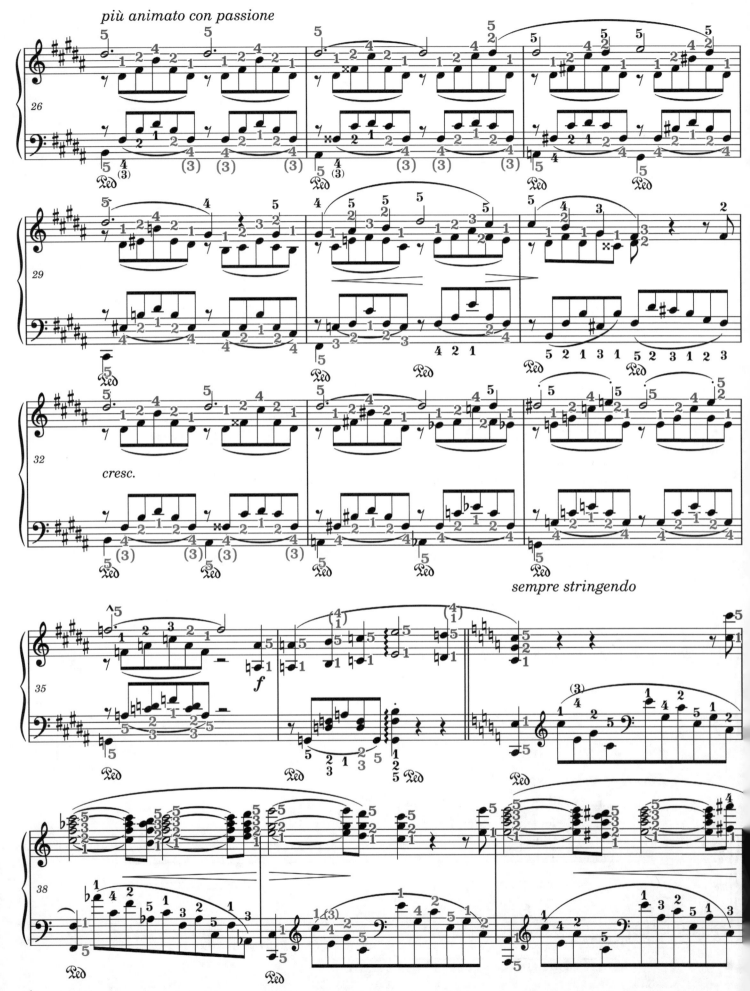

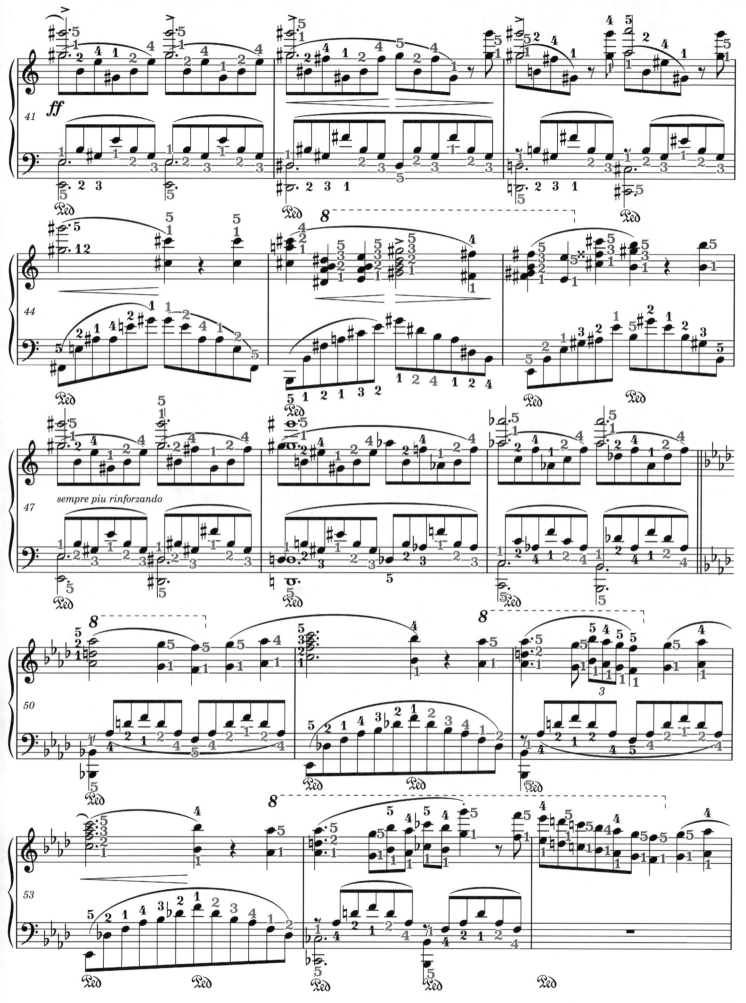

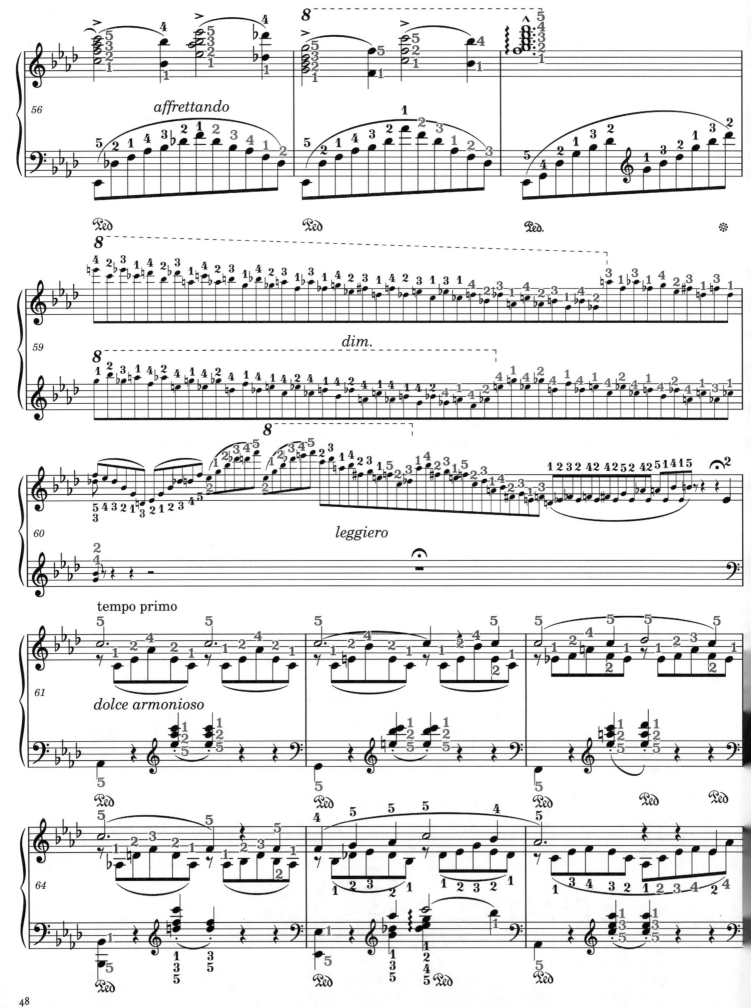

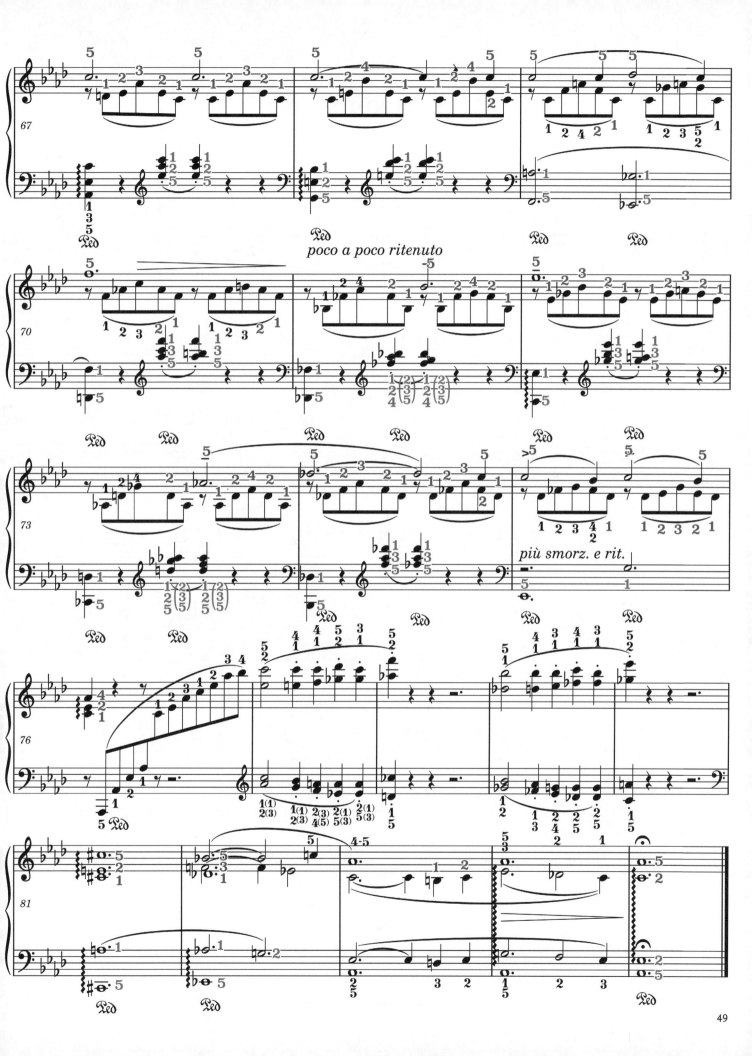

poco a poco ritenuto

più smorz. e rit.

Liebesträume No. 3

Franz Liszt
(1811–1886)

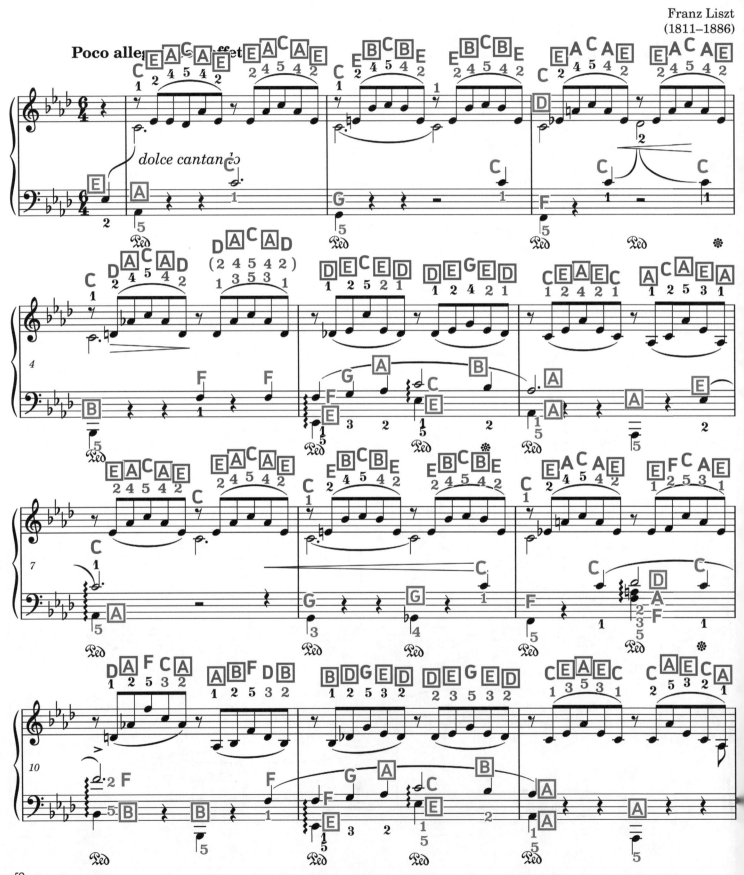

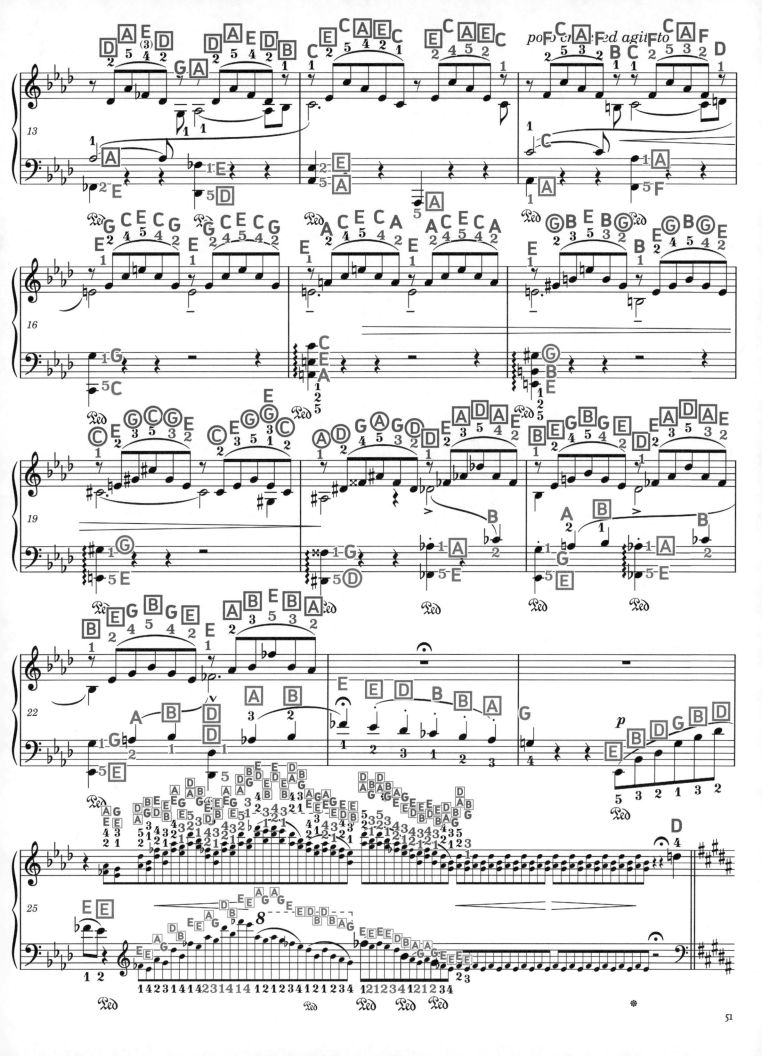

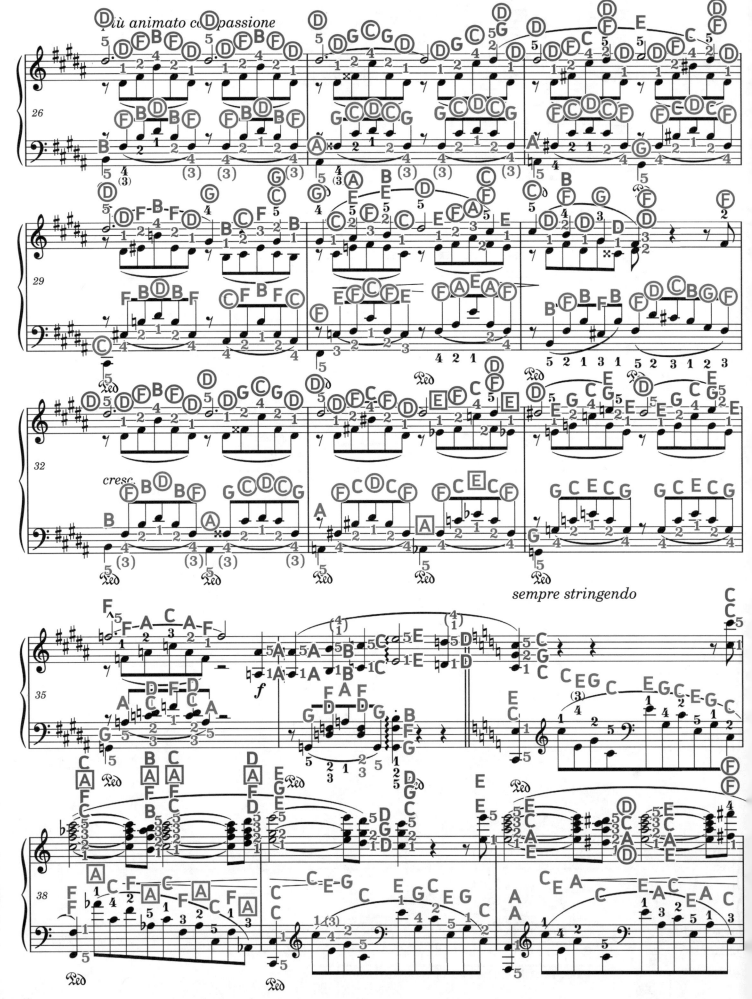

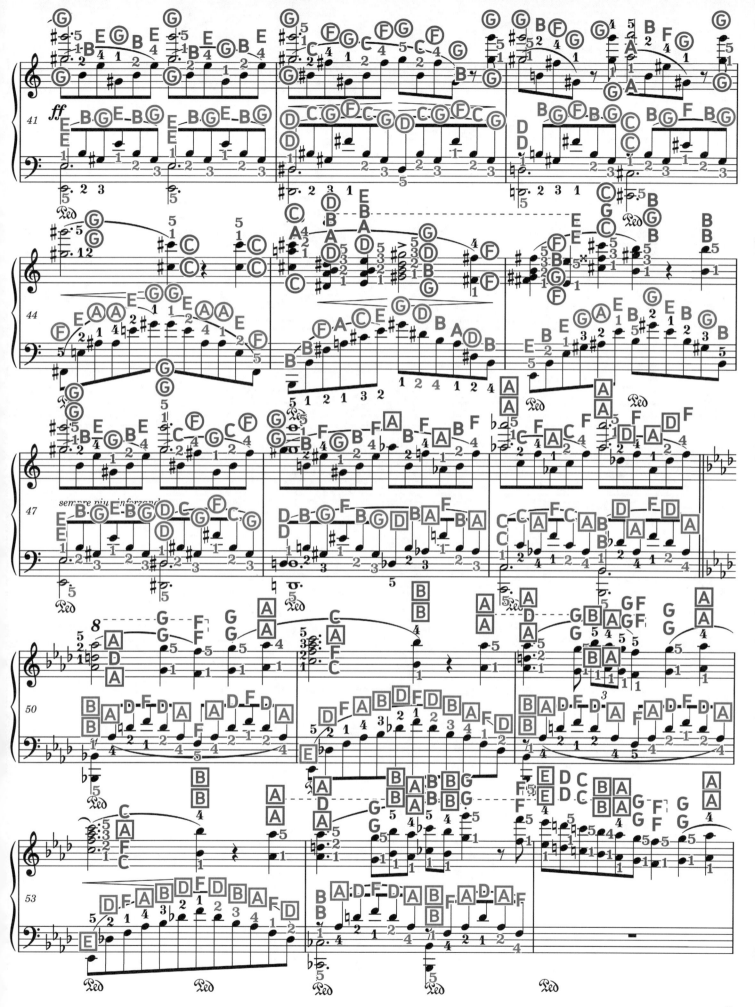

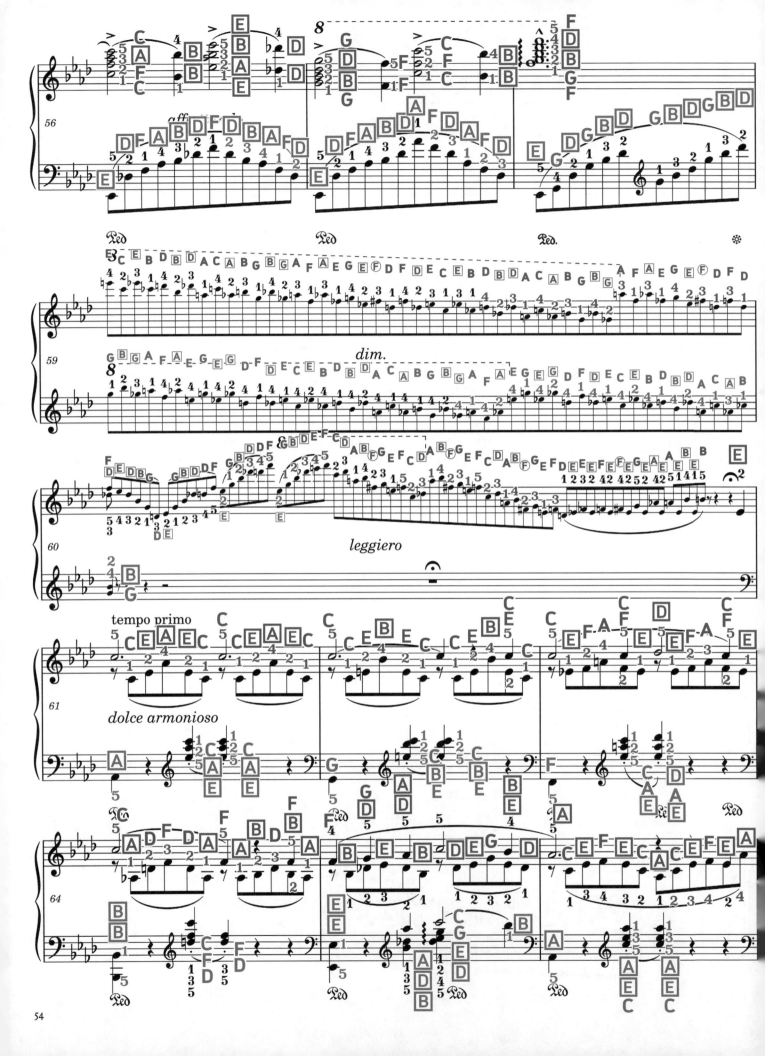

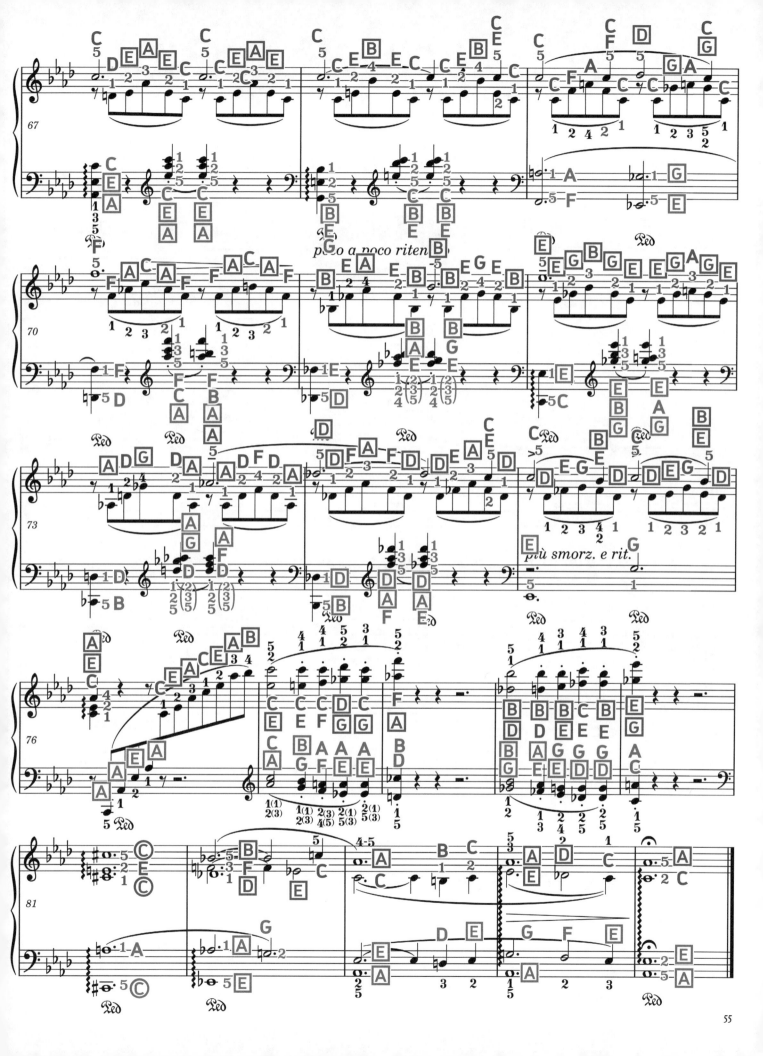

Nocturne op.9 no2

Frédéric Chopin (1810 - 1849)
Composed in E♭ major

Basic Theory: Notes & Clefs (useful knowledge before you start playing)

Notes of the Scale:
E♭, F, G, A♭, B♭, C, D

E♭ major

Key Signature:
Three Flats (B♭, E♭, A♭)

Relative Key:
C minor

Link to Audio File:
https://drive.google.com/file/d/1qGyPXkbL3
1DpV4671Q5GlVMnCRYqpdd/view?usp=sharing

Practice the scale with your <u>Right Hand (2 Octaves)</u>. Pay attention to <u>Accidentals</u> (Key Signature).

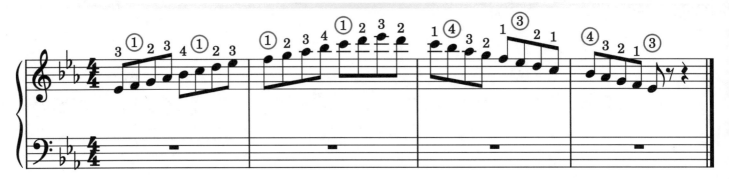

Practice the scale with your <u>Left Hand (2 Octaves)</u>. Pay attention to <u>Accidentals</u> (Key Signature).

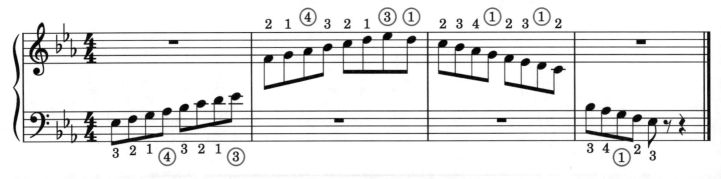

Practice Chords & Inversions (Both hands) <u>1st & 2nd Inversions: Root note 'G' & Root note 'B♭'</u>.

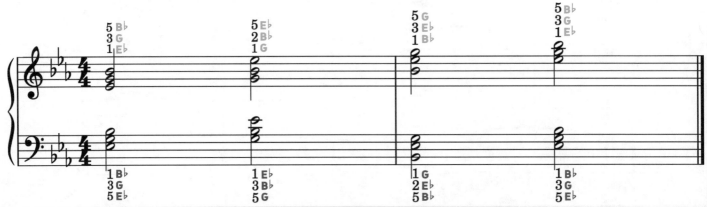

Practice Tips

Frédéric Chopin's "Nocturne Op. 9 No. 2" is a well-known Romantic piece with a lyrical melody and flowing ornamentation. It offers the chance to improve expressive phrasing and touch, conveying emotion through nuanced dynamics and rubato. Rubato is a piano technique where the tempo is flexibly adjusted, either speeding up or slowing down, to enhance the expressive quality of the music.

The following tips will help you to practice and become better.

1. START SLOW
It is very important to play each note correctly, and doing so at a low speed first helps you build the necessary muscle memory. Don't worry about keeping up with the original speed or setting a metronome.

2. FINGER NUMBERING
Pay close attention to the finger numbers, especially in the number version of your sheet music.. Remember that to play smoothly, you need to be able to place and move your hands well.

3. PAY ATTENTION TO THE RHYTHM
A metronome can be very helpful. Set the speed to a low level first, and as you get used to the beats, slowly speed it up.

4. BREAK IT DOWN
Focus on small areas at a time. Mastering a few measures at a time can help you feel more confident and make sure you play correctly.

5. SEPARATE, THEN TOGETHER
Work on each hand separately to focus on its difficulties. As soon as you feel ready, start playing with both hands.

6. READ THE NOTES
Practice reading the original score. If you are unsure, go to the third version and look up the name.
This helps you become a better musician, learn more songs in the future, and move past the beginning level.

7. SAY OR SING
Say or sing the note names out loud as you play from the version with the note names.
This will help you remember where the sounds are on the piano and the staff.

8. RECORD YOURSELF
Document your practice lessons from time to time so you see what you need to work on and how you're doing by listening back over time.

9. REGULAR PRACTICE
It's important to practice often. Also, having short daily practices is better than long ones less often. Being consistent is key and will bring you the best results.

10. THINK ABOUT FINGER TRANSITIONS
Consider how the fingers change places, especially where the finger numbers are shown. Composers also include those numbers in original scores because your performance will sound better and flow better if you use smooth changes.

Nocturne Op.9 No.2

Chopin

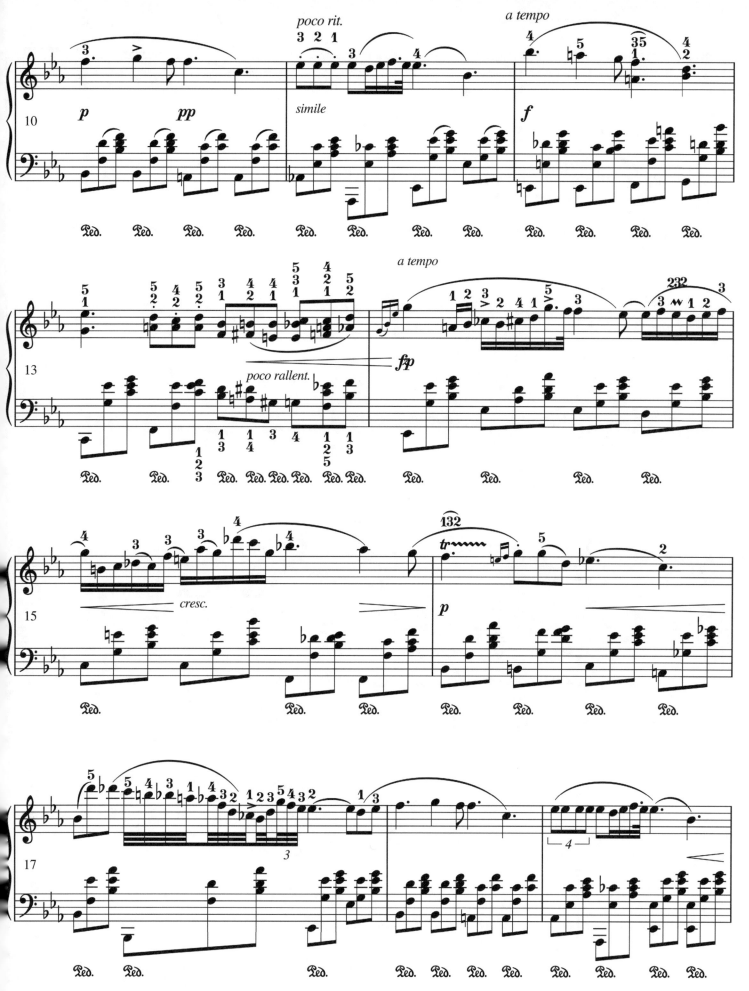

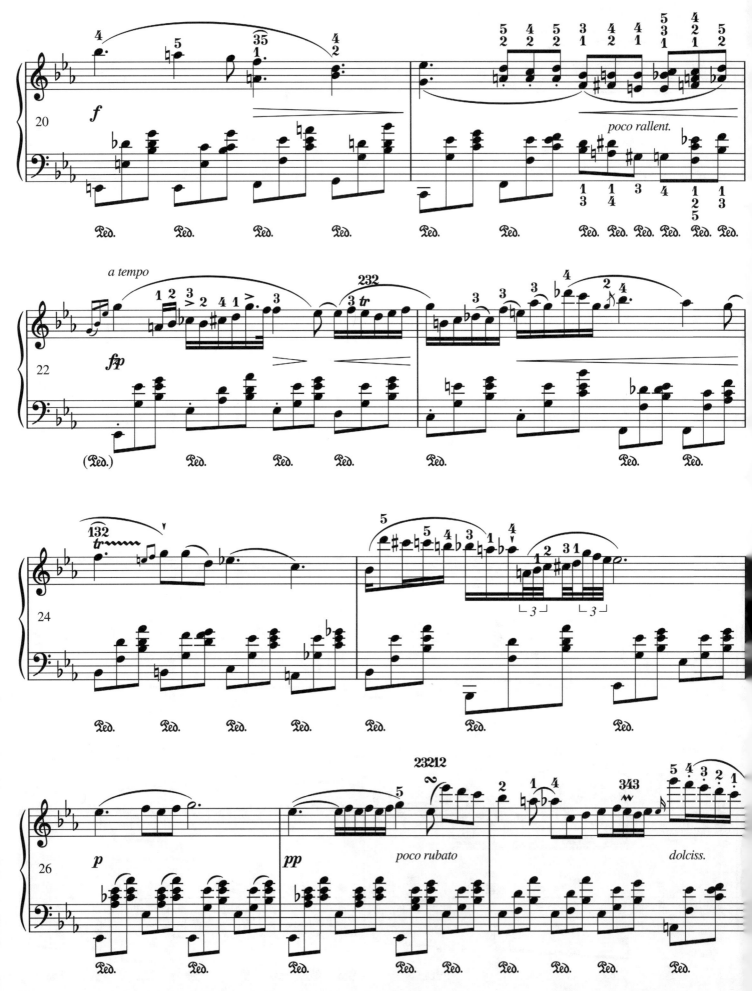

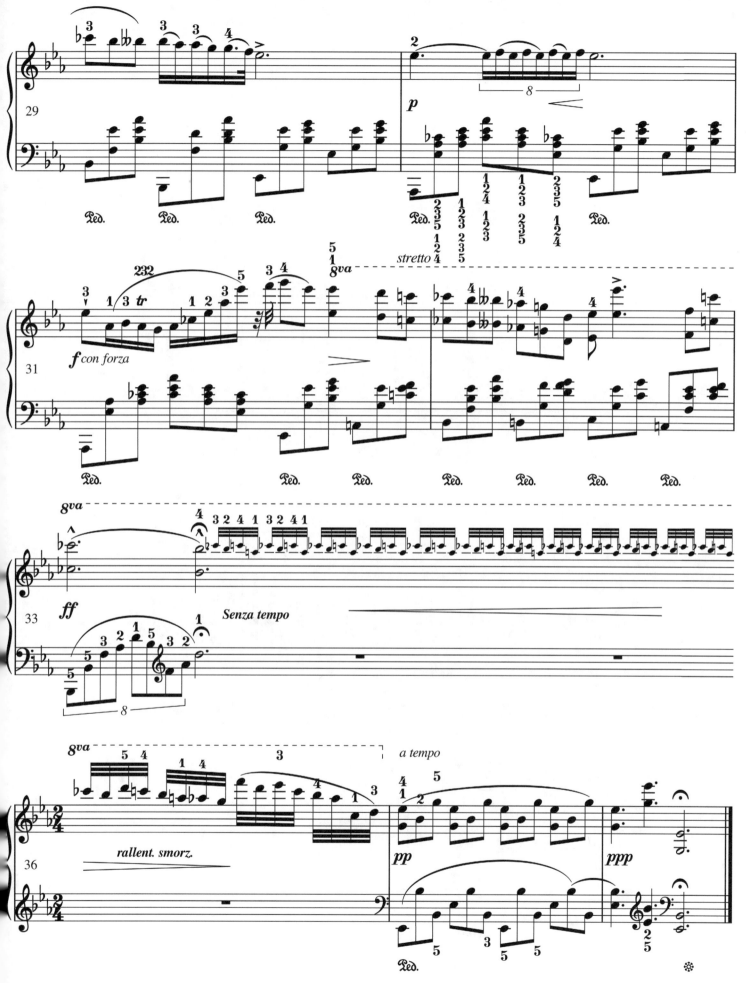

Nocturne Op.9 No.2

Chopin

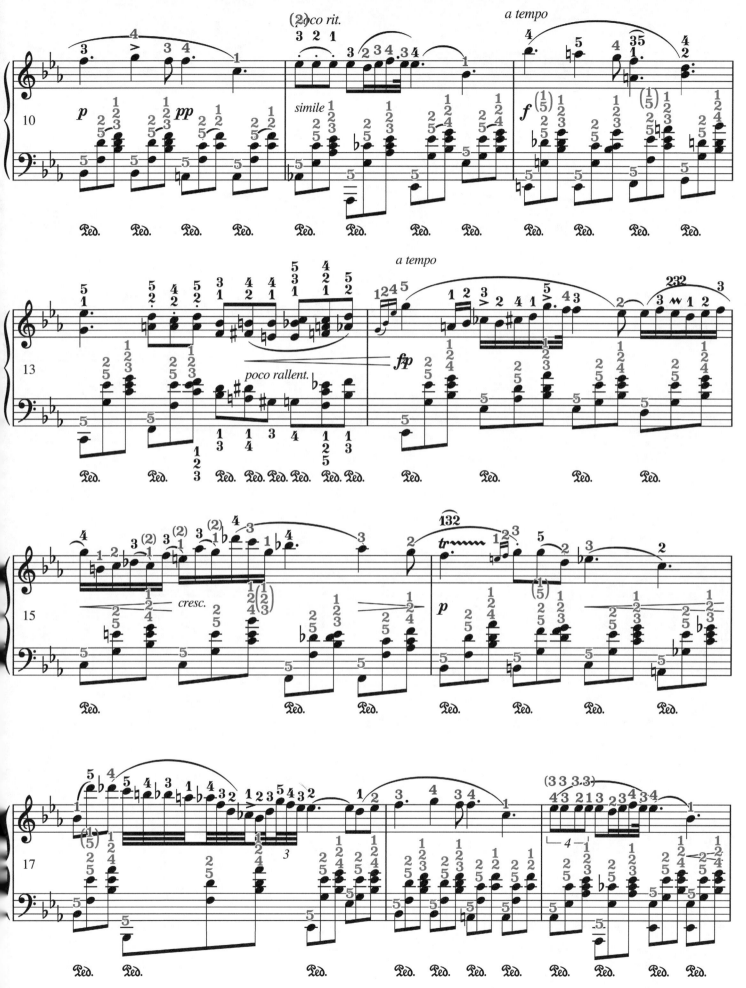

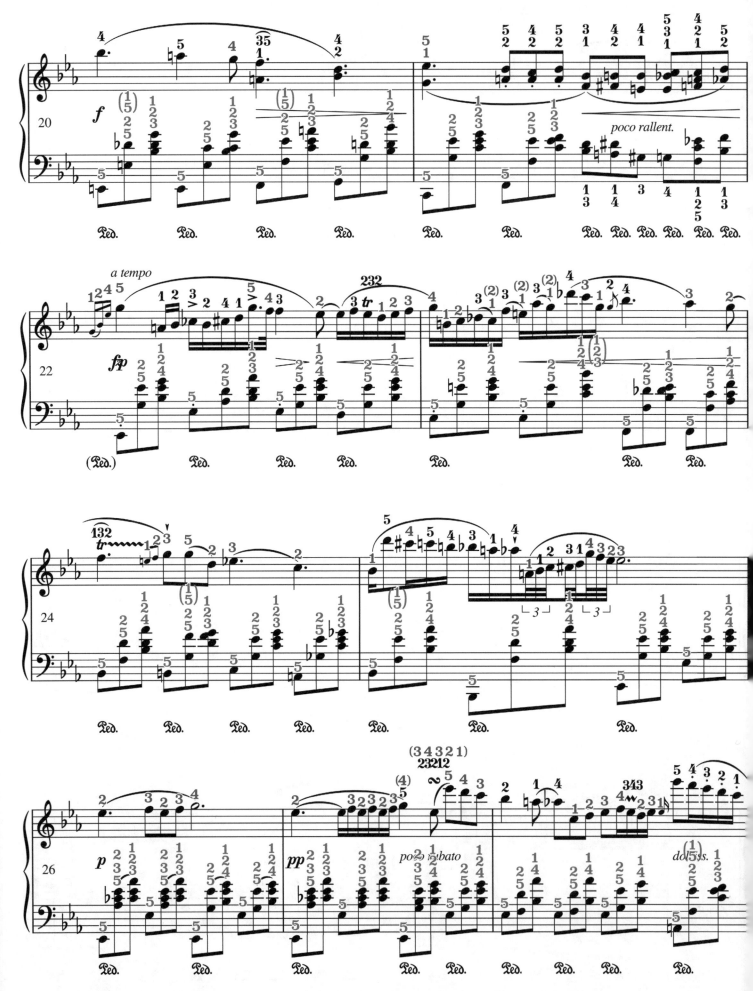

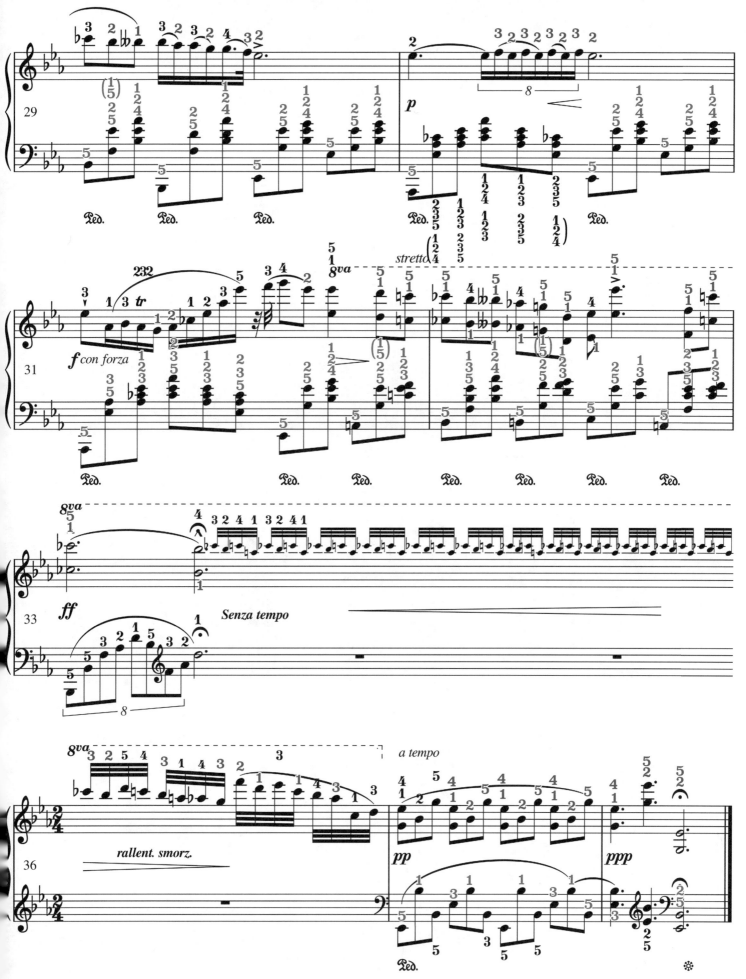

Nocturne Op.9 No.2

Chopin

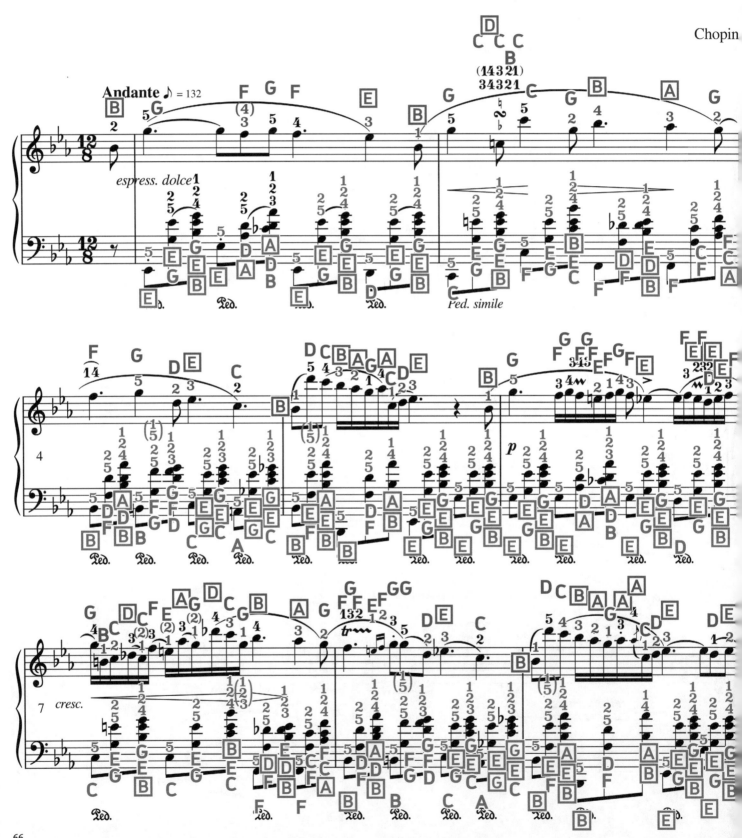

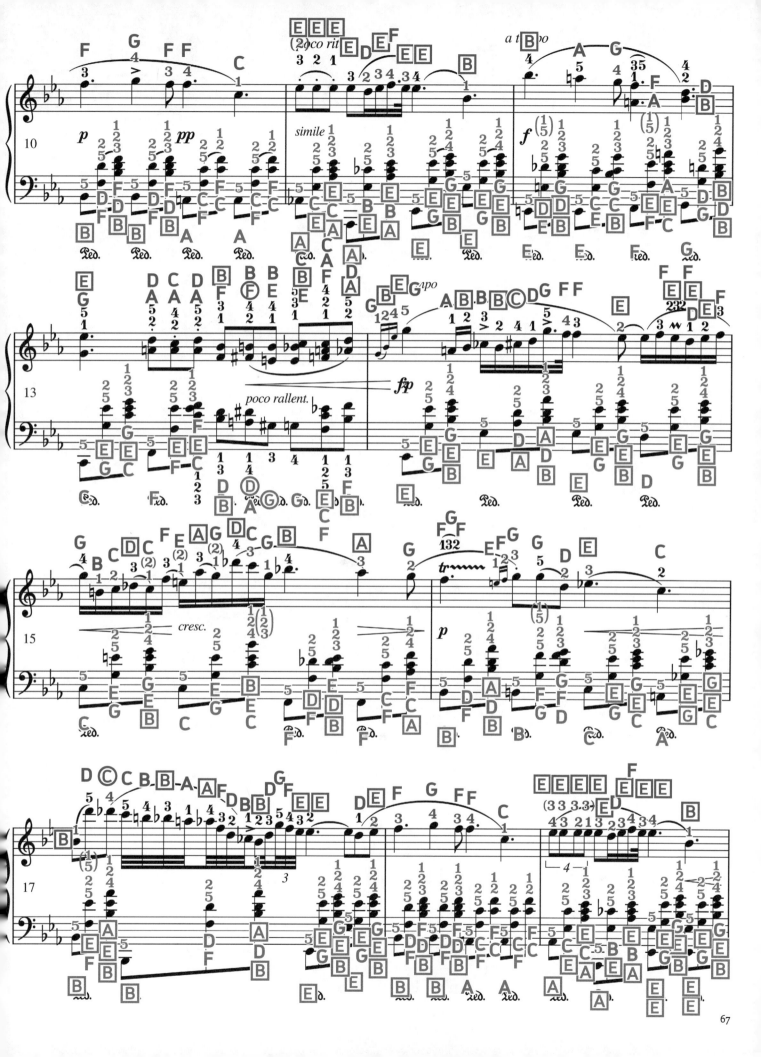

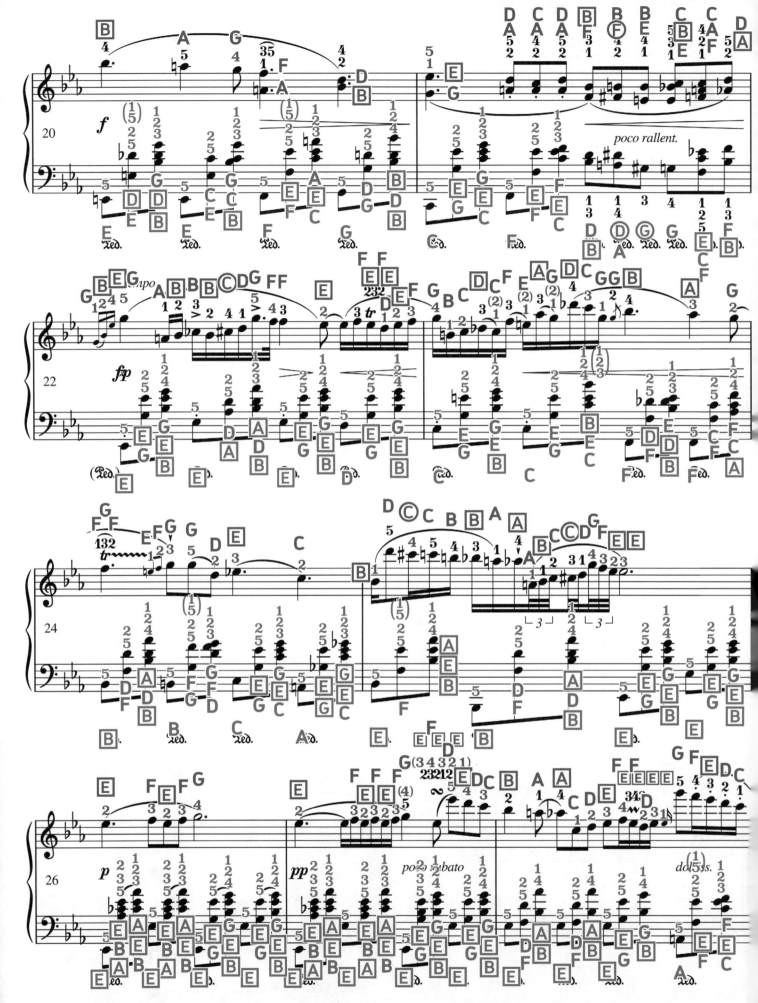

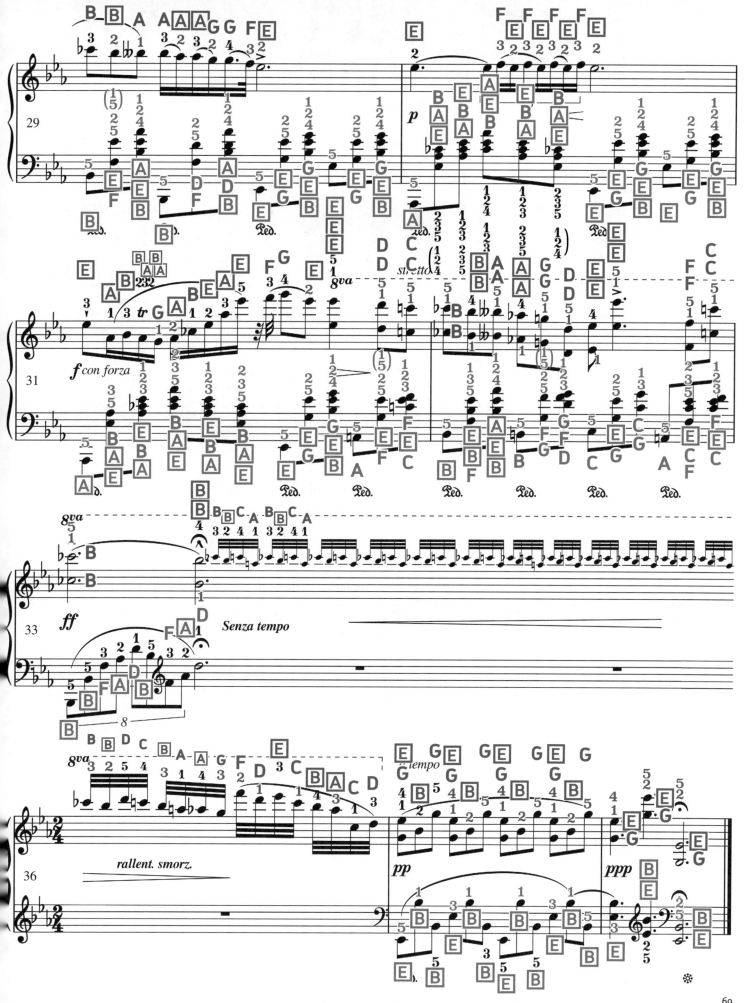

CLAIR DE LUNE

CLAUDE DEBUSSY (1862 - 1918)

Composed in Db major

BASIC THEORY: NOTES & CLEFS (USEFUL KNOWLEDGE BEFORE YOU START PLAYING)

Notes of the Scale:

Db, Eb, F, Gb, Ab, Bb, C

Key Signature:

Five Flats (Bb, Eb, Ab, Db, Gb)

Relative Key:

Bb minor

Link to Audio File:

https://drive.google.com/file/d/1jFrh
e0zM0M2PrkNo9amHgvTVfsHTTo_/view

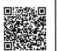

Practice the scale with your <u>RIGHT HAND (2 OCTAVES)</u>. Pay attention to <u>ACCIDENTALS (Key Signature)</u>.

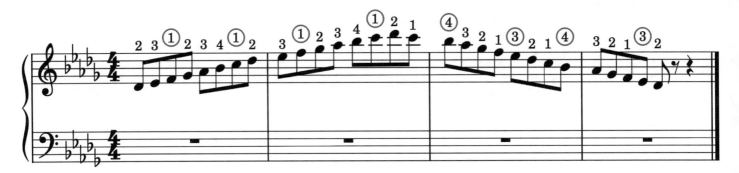

Practice the scale with your <u>LEFT HAND (2 OCTAVES)</u>. Pay attention to <u>ACCIDENTALS (Key Signature)</u>.

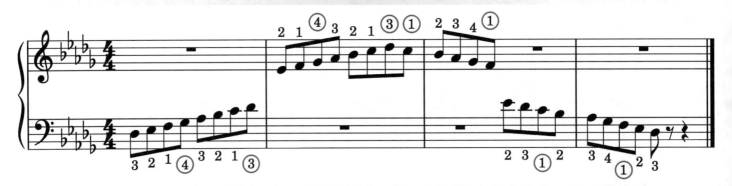

Practice CHORDS & INVERSIONS (BOTH HANDS) <u>1st & 2nd Inversions: Root note 'F' & Root note 'Ab'</u>.

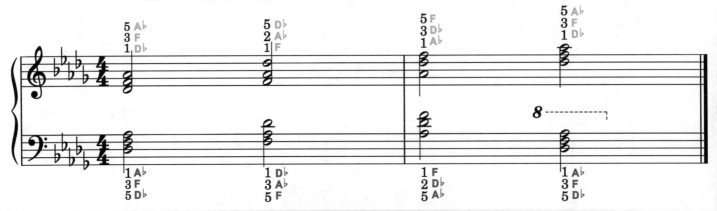

PRACTICE TIPS

"Clair de Lune," composed by Claude Debussy in 1890, translates to "Moonlight". The piece's gentle, undulating rhythms and lush harmonies provide a wonderful opportunity for pianists to develop expressive control and convey a sense of calm introspection, making it a favorite for those seeking to deepen their emotional connection to the music.

The following tips will help you to practice and become better.

1. START SLOW

It is very important to play each note correctly, and doing so at a low speed first helps you build the necessary muscle memory. Don't worry about keeping up with the original speed or setting a metronome.

2. FINGER NUMBERING

Pay close attention to the finger numbers, especially in the number version of your sheet music.. Remember that to play smoothly, you need to be able to place and move your hands well.

3. PAY ATTENTION TO THE RHYTHM

A metronome can be very helpful. Set the speed to a low level first, and as you get used to the beats, slowly speed it up.

4. BREAK IT DOWN

Focus on small areas at a time. Mastering a few measures at a time can help you feel more confident and make sure you play correctly.

5. SEPARATE, THEN TOGETHER

Work on each hand separately to focus on its difficulties. As soon as you feel ready, start playing with both hands.

6. READ THE NOTES

Practice reading the original score. If you are unsure, go to the third version and look up the name. This helps you become a better musician, learn more songs in the future, and move past the beginning level.

7. SAY OR SING

Say or sing the note names out loud as you play from the version with the note names. This will help you remember where the sounds are on the piano and the staff.

8. RECORD YOURSELF

Document your practice lessons from time to time so you see what you need to work on and how you're doing by listening back over time.

9. REGULAR PRACTICE

It's important to practice often. Also, having short daily practices is better than long ones less often. Being consistent is key and will bring you the best results.

10. THINK ABOUT FINGER TRANSITIONS

Consider how the fingers change places, especially where the finger numbers are shown. Composers also include those numbers in original scores because your performance will sound better and flow better if you use smooth changes.

Clair de Lune

from "Suite Bergamasque" L. 75
3rd Movement

Claude Debussy
(1862–1918)

Andante très expressif

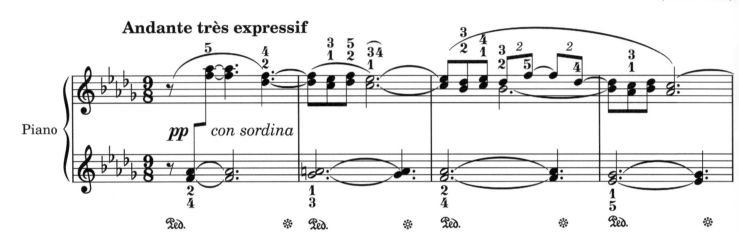

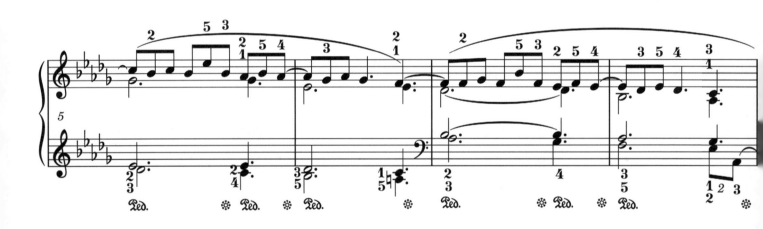

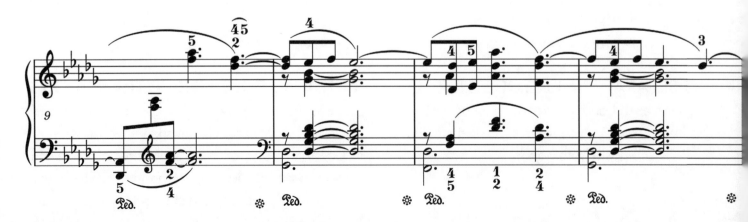

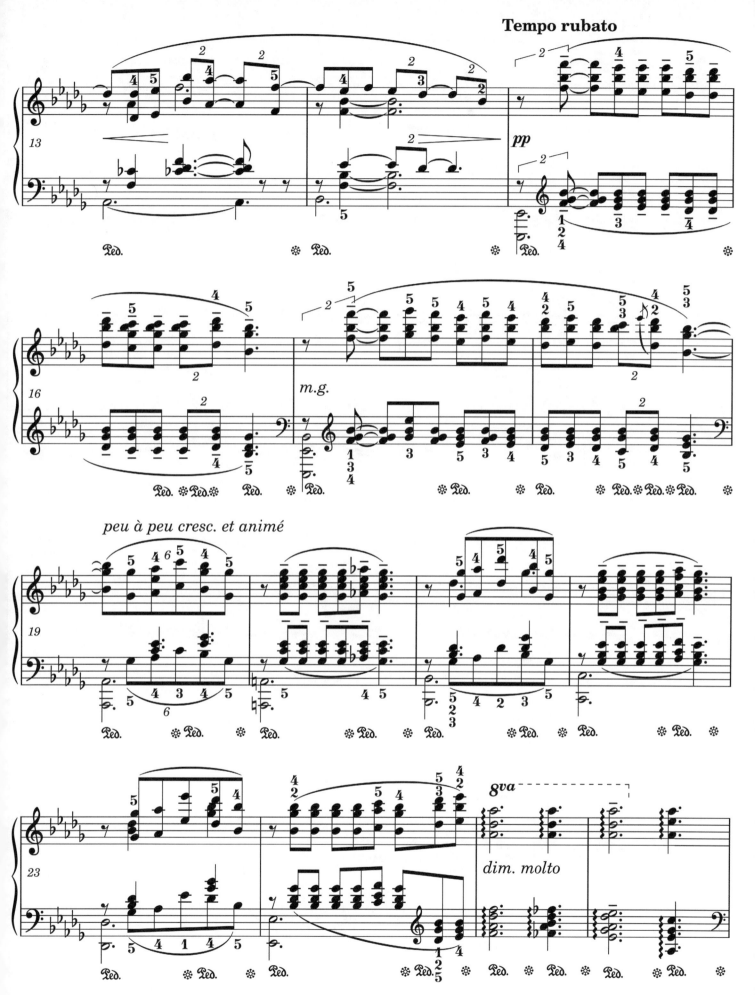

Tempo rubato

73

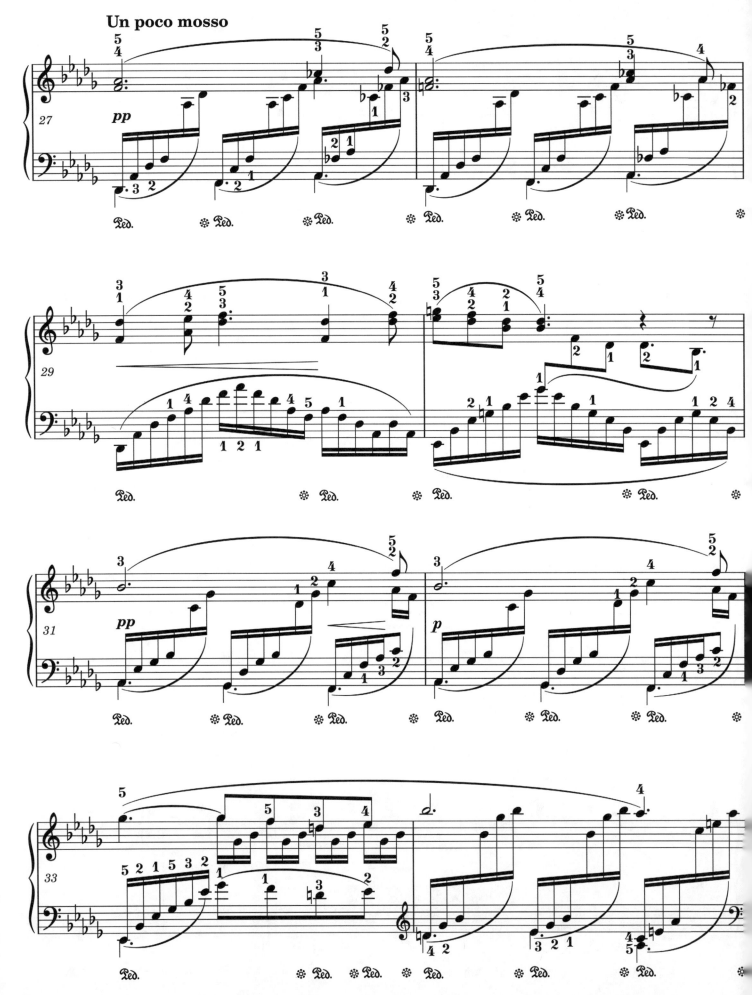

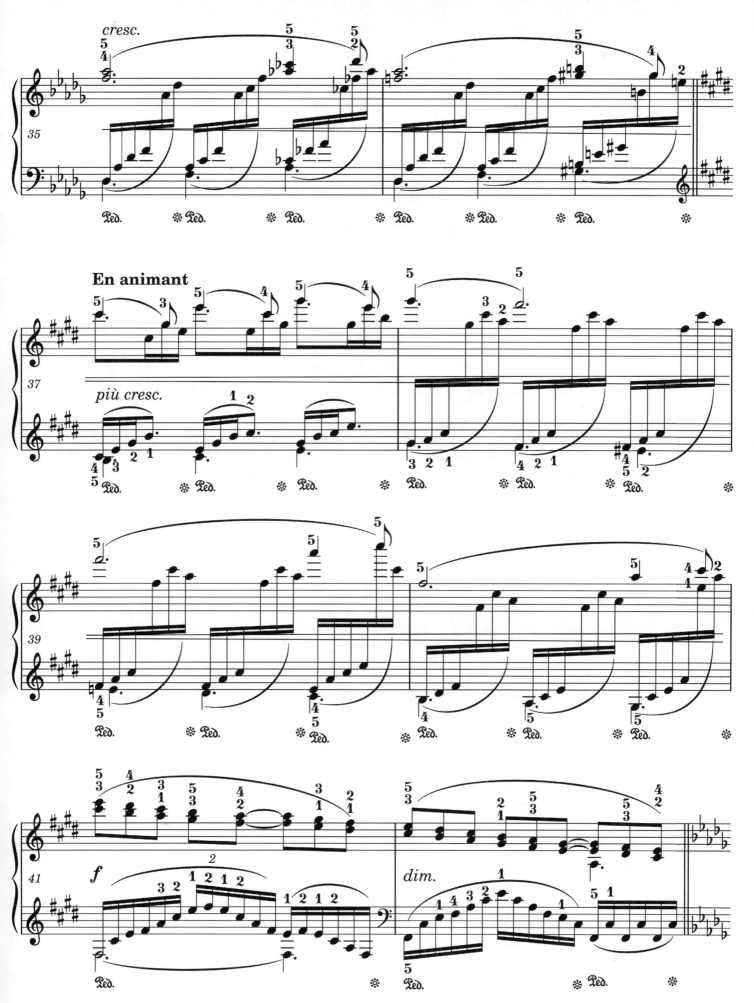

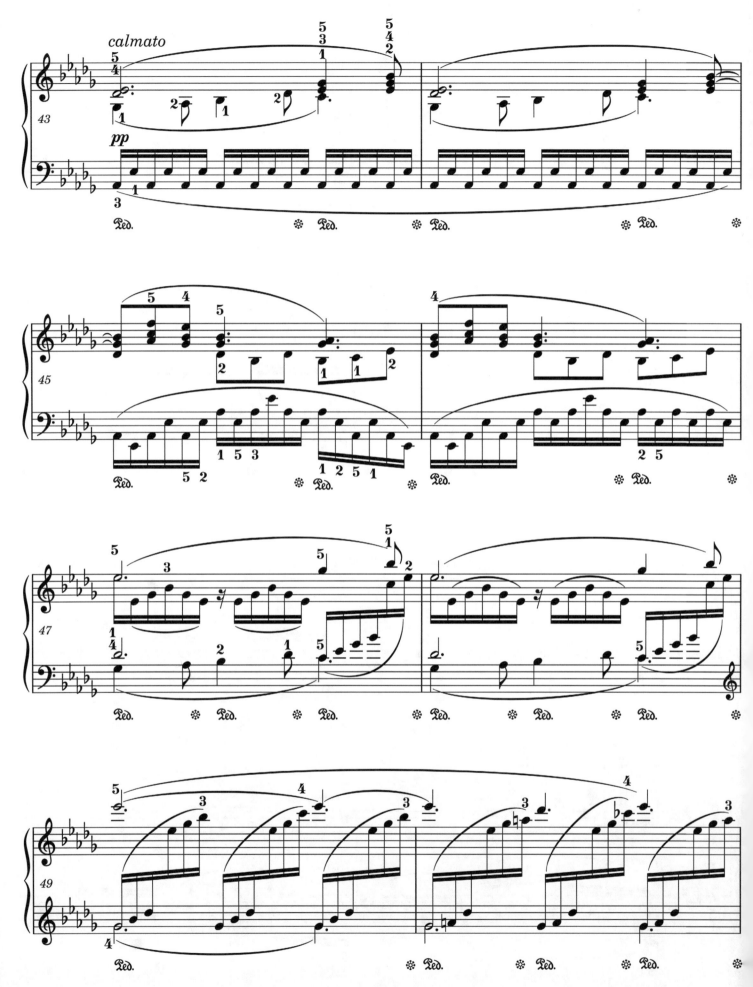

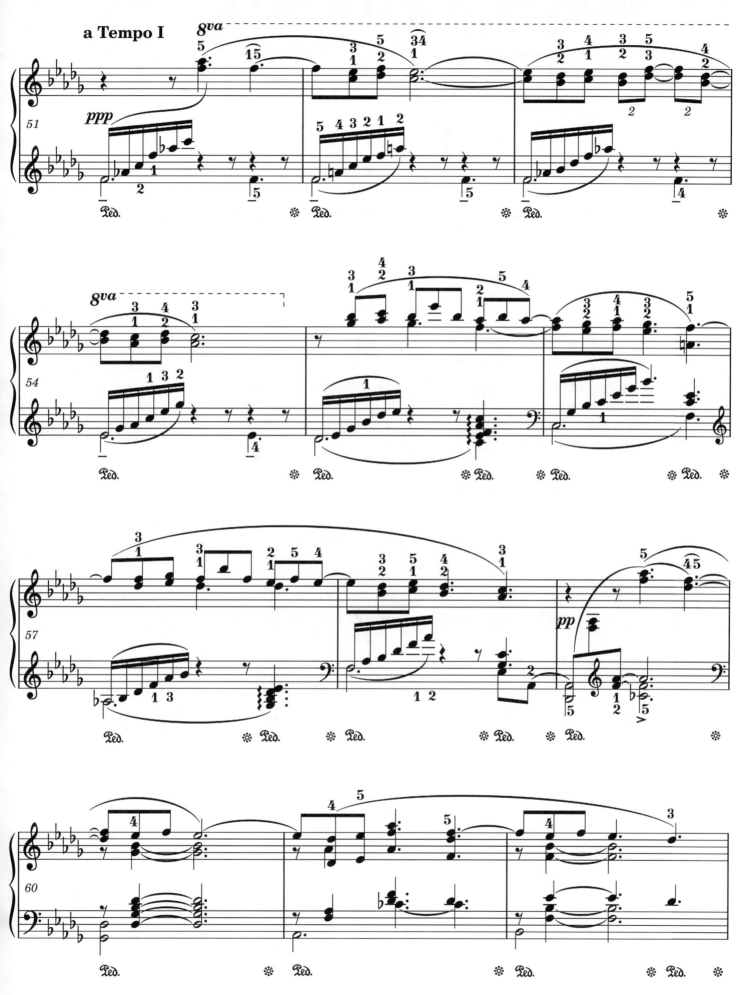

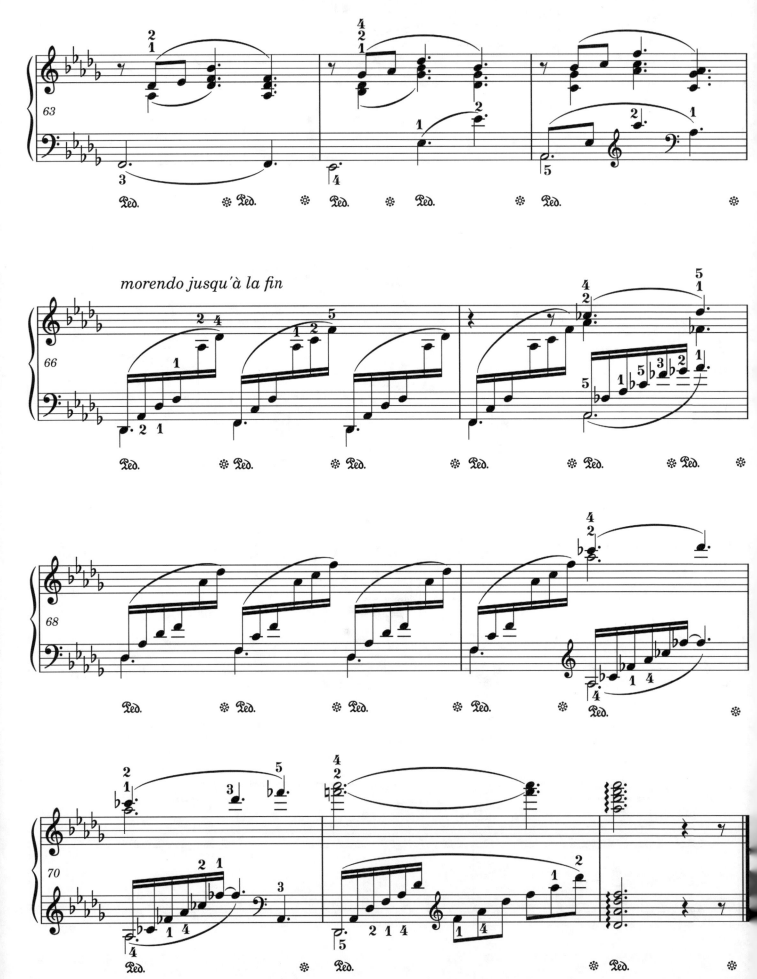

morendo jusqu'à la fin

Clair de Lune

from "Suite Bergamasque" L. 75
3rd Movement

Claude Debussy
(1862–1918)

Andante très expressif

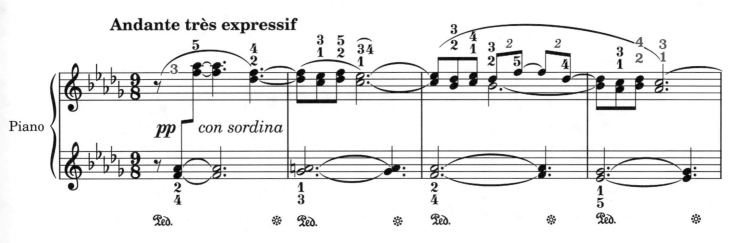

Piano

pp *con sordina*

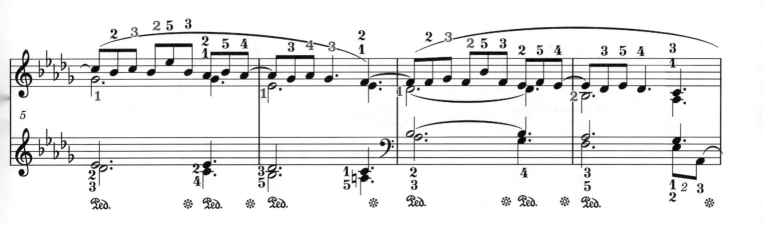

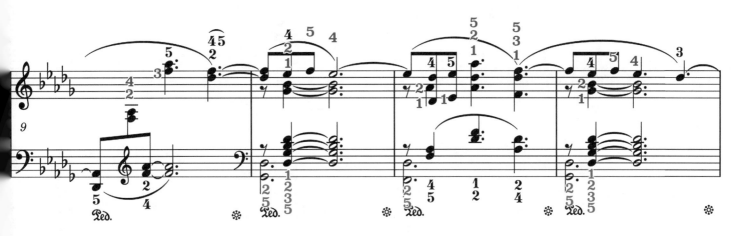

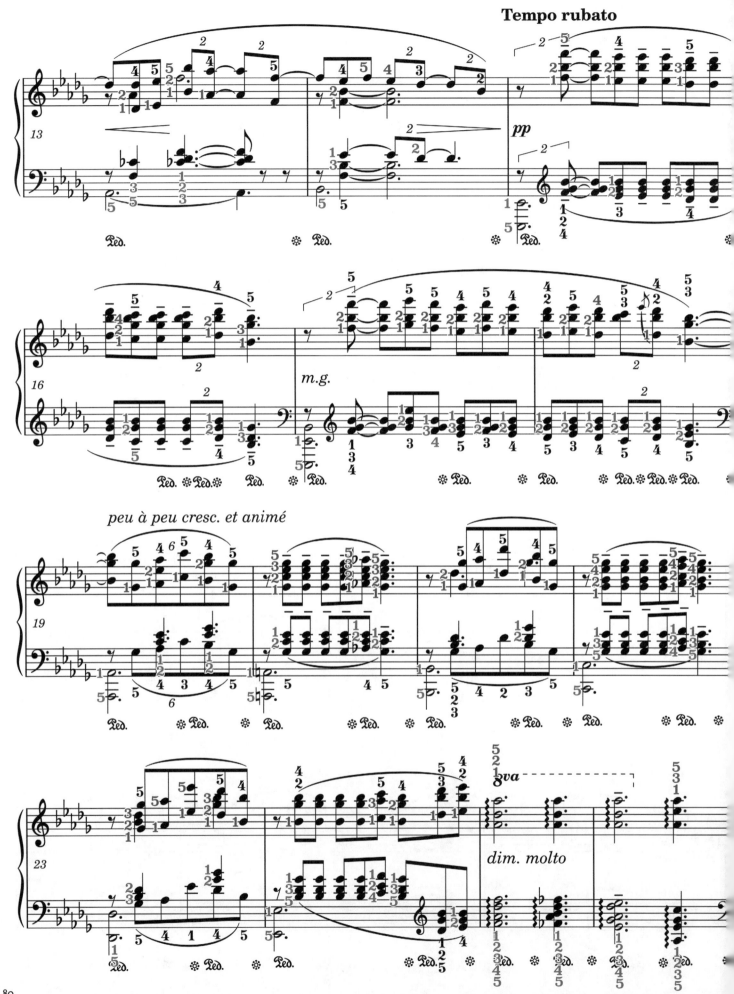

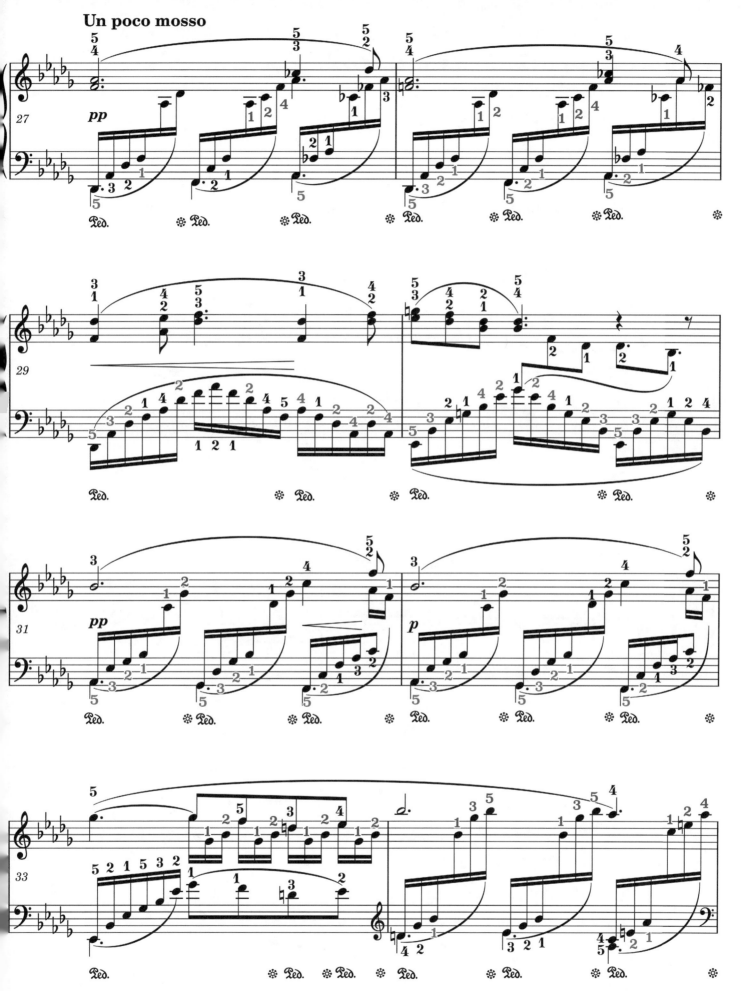

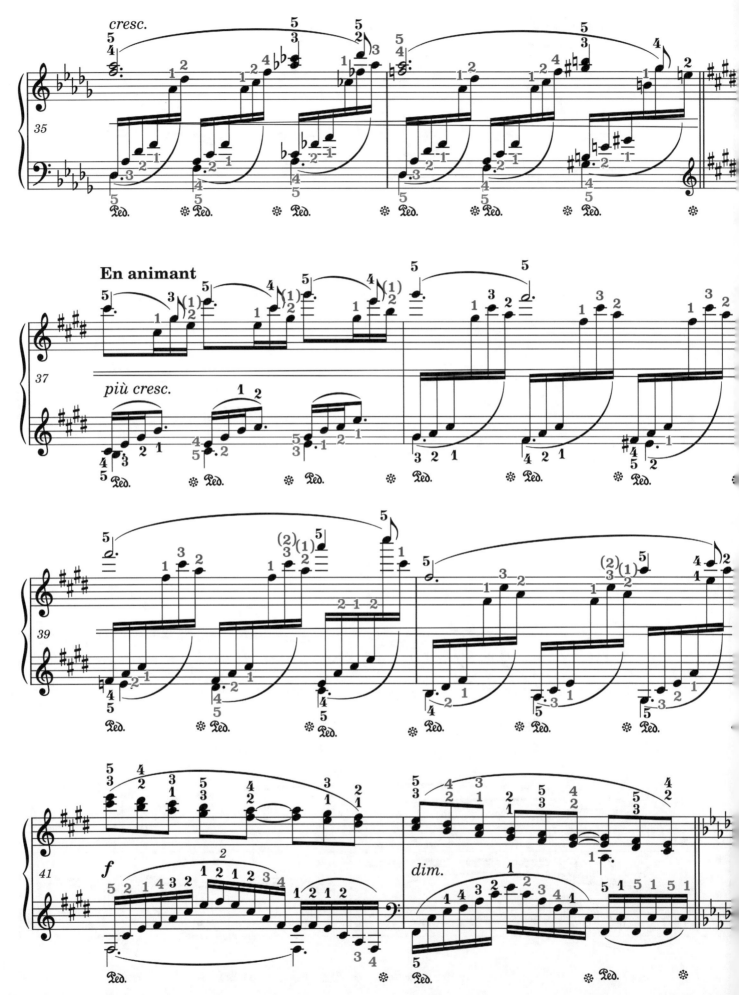

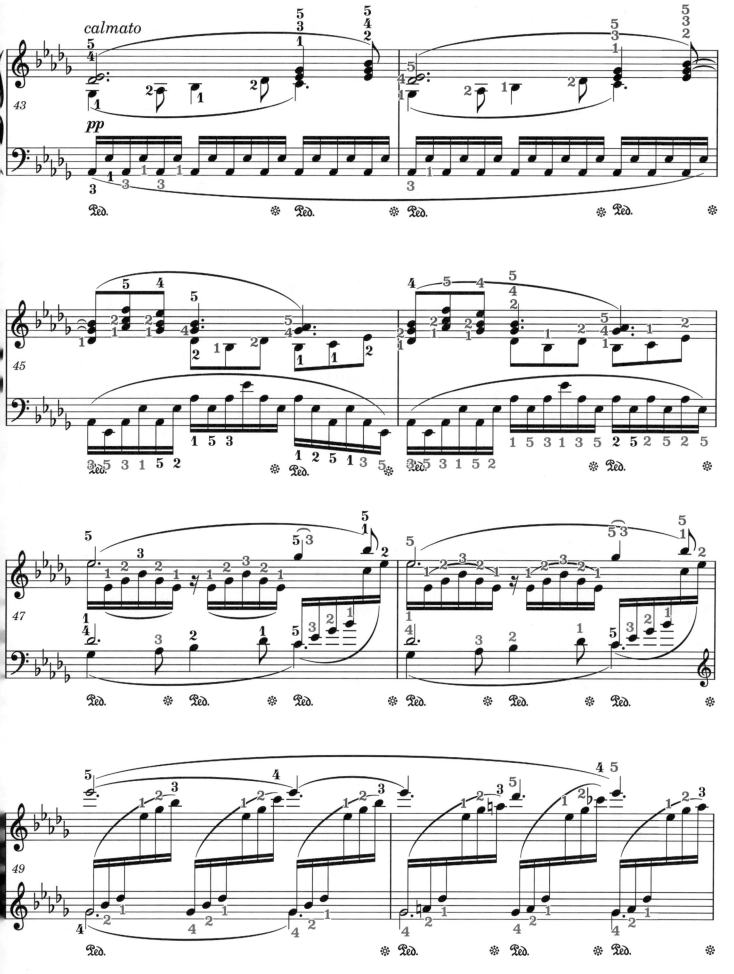

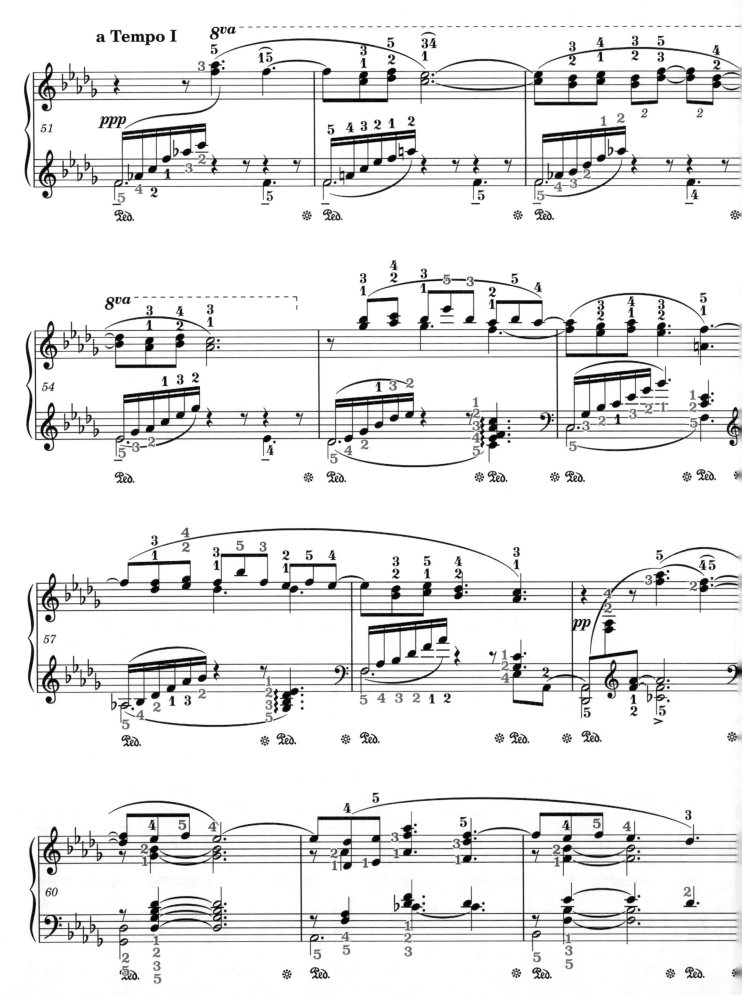

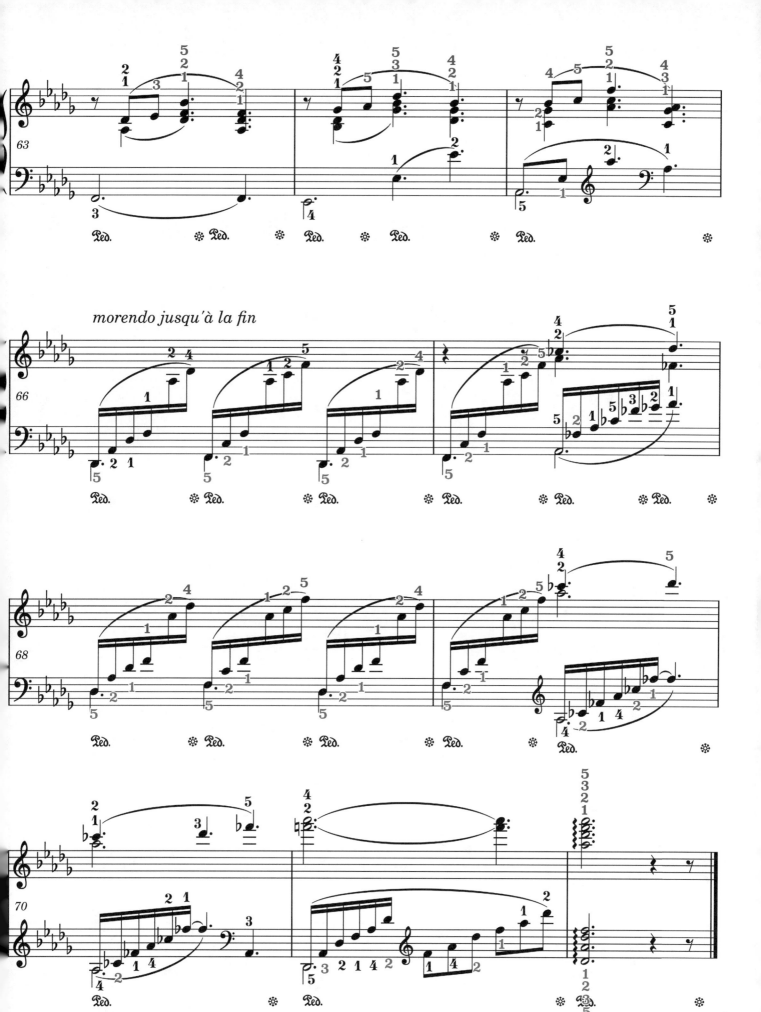

morendo jusqu'à la fin

Clair de Lune

from "Suite Bergamasque" L. 75
3rd Movement

Claude Debussy
(1862–1918)

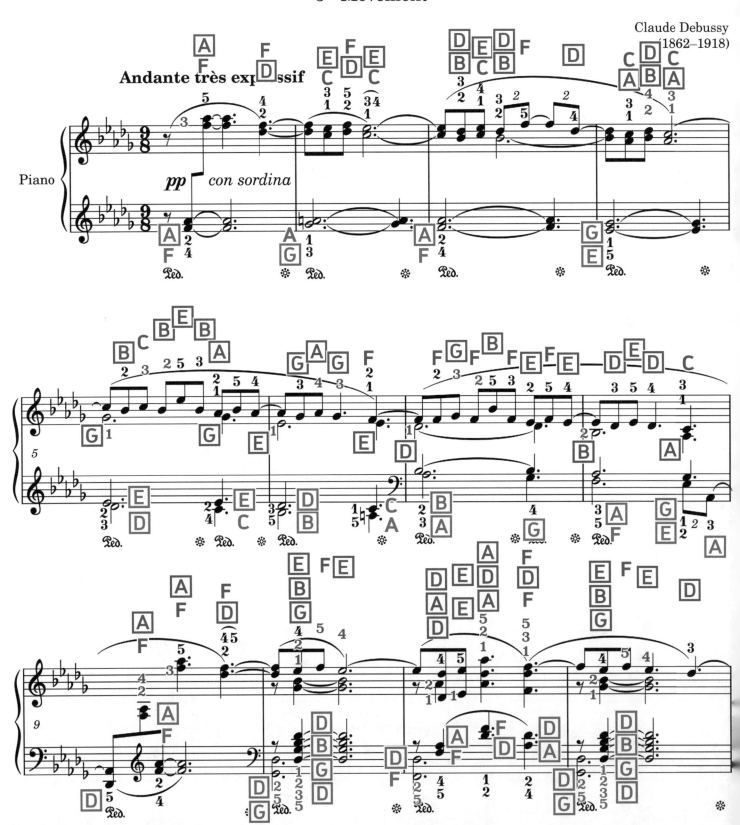

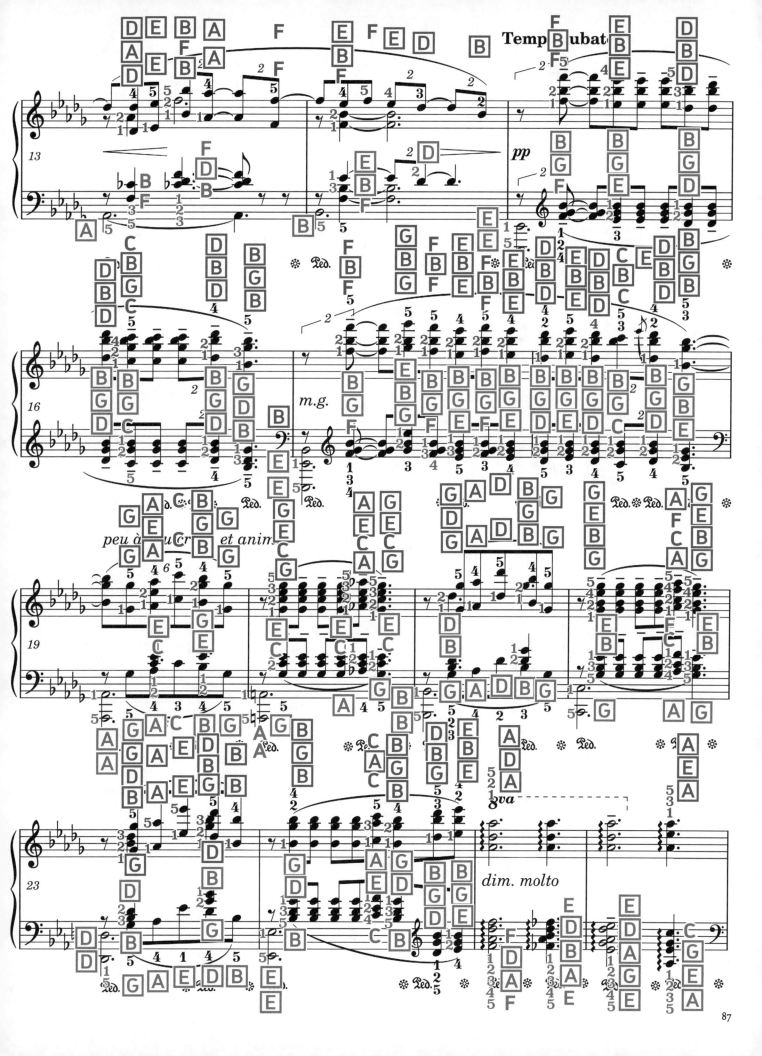

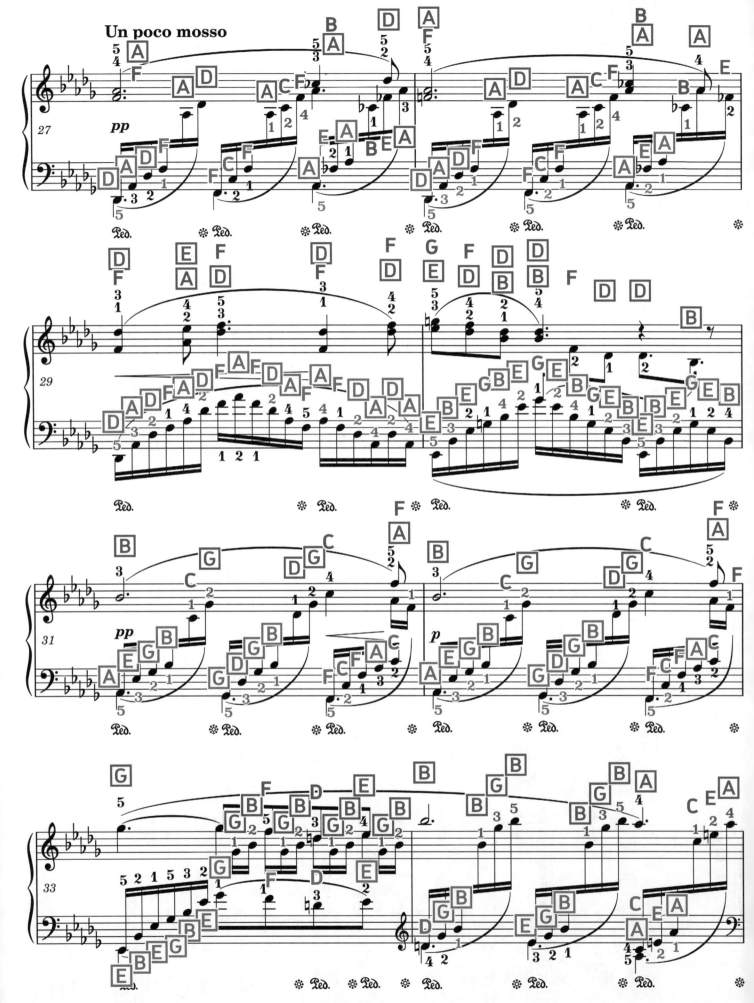

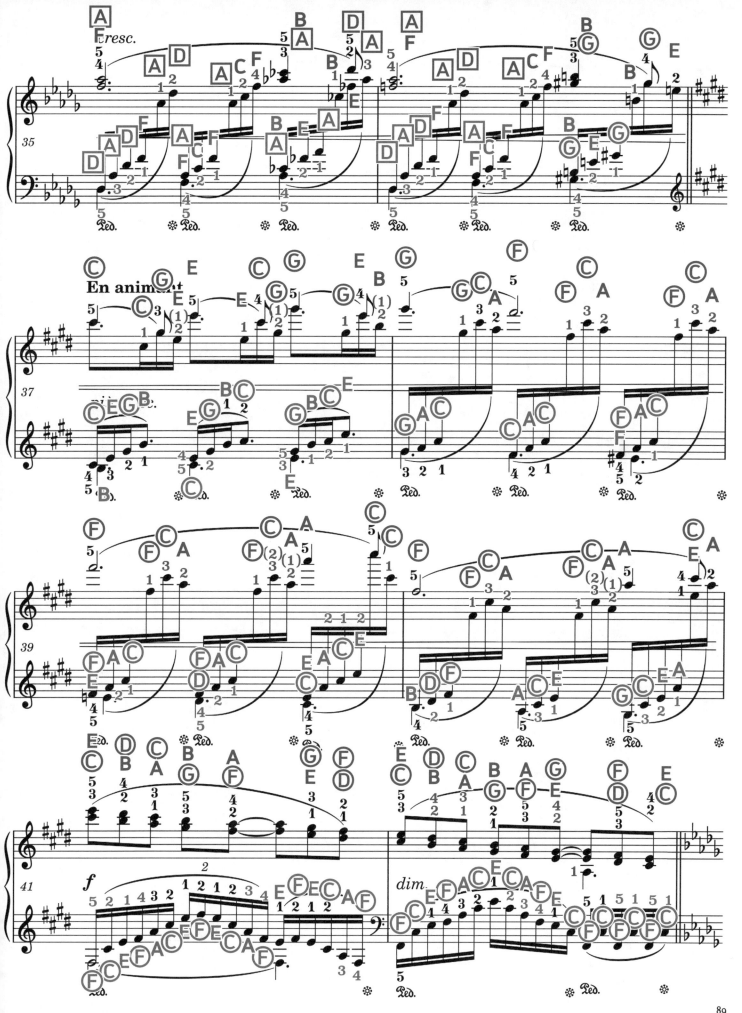

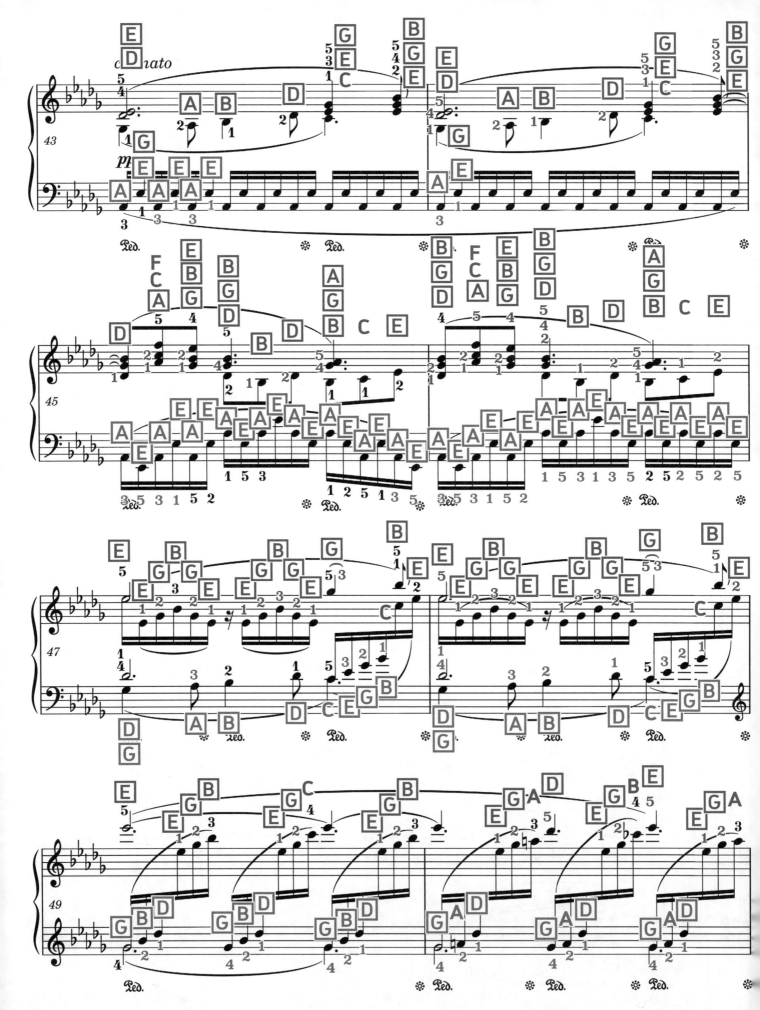

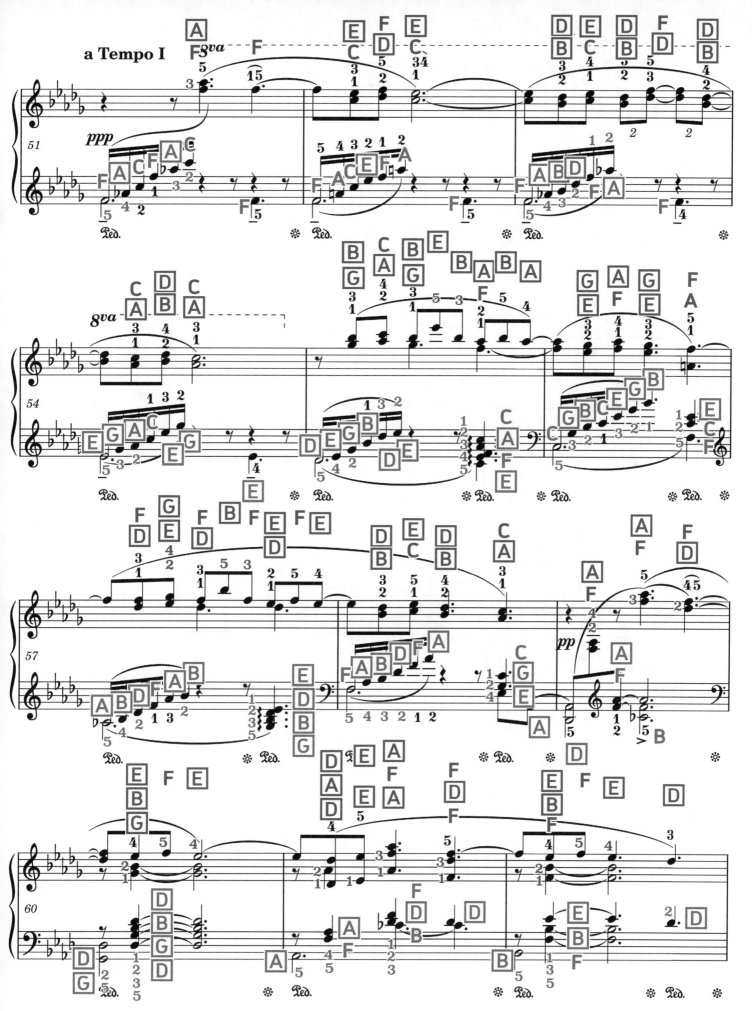

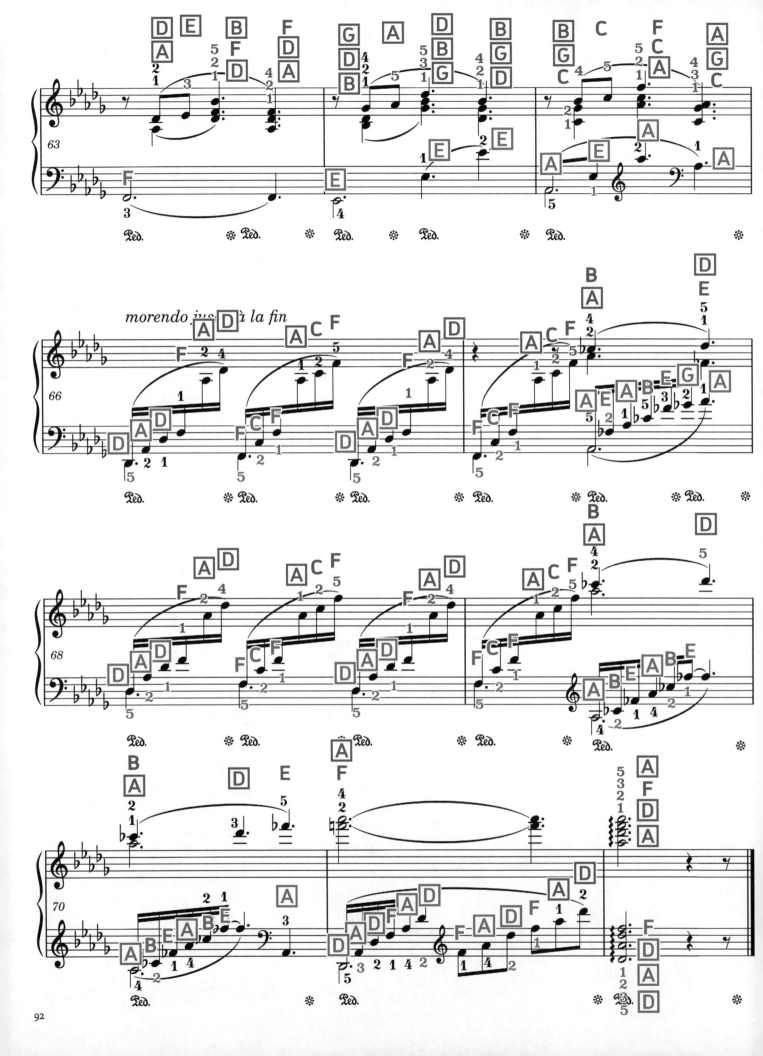

- The End -

Congratulations!

You've made it to the end of this book.

Just keep in mind, it takes a master to even play "easy" music truly beautiful.

We hope you practice joyfully and continue to learn.

I wish you the best of luck on your musical journey.

*If you found this book helpful in your practice
please leave us a review.*

For more songs - sheet music - books - Go visit:

www.HermannPress.com

Made in United States
Troutdale, OR
09/11/2024